D0198825

IMAGES
of America

PINOLE

Thank You!
Pinole**Historical**Society
P.O. Box 285, Pinole, CA 94564
www.PinoleHistoricalSociety.org

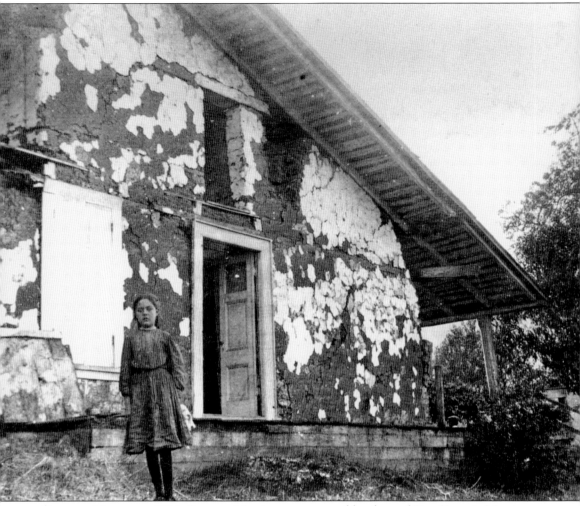

RAMONA MARTINEZ, 1911. Ramona Martinez, great-granddaughter of Don Ygnacio Martinez, stands amid the ruins of her family adobe in the Pinole Valley. She was 11 in this photograph; she died of cancer at the age of 18. She was the last Martinez to live at the adobe, which was built in the mid-1830s. (George Vincent.)

ON THE COVER: Pinole historically was the scene of many parades. This one was a Fourth of July parade on Tennent Avenue, proceeding south, in the early 1900s. Undoubtedly it was led by the Pinole Municipal Band, which was at the forefront of many parades. The building with the triangular facade behind the car carrying the women is the American Hotel. It burned down in 1929. (George Vincent.)

IMAGES
of America

PINOLE

Joseph Mariotti, George Vincent, Jeff Rubin,
and the Pinole Historical Society

ARCADIA
PUBLISHING

Published by Arcadia Publishing
Charleston SC, Chicago IL, Portsmouth NH, San Francisco CA

Printed in the United States of America

Library of Congress Control Number: 2009921920

For all general information contact Arcadia Publishing at:
Telephone 843-853-2070
Fax 843-853-0044
E-mail sales@arcadiapublishing.com
For customer service and orders:
Toll-Free 1-888-313-2665

Visit us on the Internet at www.arcadiapublishing.com

JESSIE HOWE CLARK, WRITER AND HISTORIAN. Jessie arrived in Pinole on the train in 1913 and immediately began chronicling the city's history, first for the *Pinole Weekly Times* and then for the *Pinole-Hercules News*, which was founded in 1946. She was named Pinole's official historian and poet laureate at the city's 1973 Historical Appreciation Day. Her newspaper clippings are on microfilm at the Pinole Library. Jesse was born on March 17, 1890. She died on December 15, 1987 at age 97. (Joe Mariotti.)

CONTENTS

ACKNOWLEDGMENTS

The citizens of Pinole owe a tremendous debt of gratitude to Dr. Joseph Mariotti, whose extensive collection of photographs of the city's history, dating back to the 19th century, made this book project possible. Dr. Joe and George Vincent, Pinole's historians, cofounded the Pinole Historical Society in 1974 and kept it running for several decades. George wrote much of the text in this book. Now, with their help, the Pinole Historical Society is working toward the establishment of a municipal museum where Pinole's history can be displayed and studied by the entire community.

Many individuals and organizations contributed photographs and knowledge to this book. They include Applebee's, Edward Armstrong, Ollie Armstrong, Deanna (Faria) Brownlee, Jim Brownlee, Don and Ida Castro, Charles Christopher, City of Pinole (Patti Athenour, Lynda Curtis, Mary Drazba, and Wanda Olson), Patti Clark, Contra Costa Historical Society, Wayne Doty, Allen Faria, Susan Fernandez, Sheila Grist, Sonny Jackson, Alex Jason, Marcia Kalapus, Sterling Kelley, Mike LeFebvre, Bob Marieiro, Joe Mariotti, Anna McCarty, Floyd McCarty, Mechanics Bank (Barbara Cronin and Edward M. Downer III), Norma Martínez-Rubin, Jack Meehan, Bill Miller, Robert Morris, Debbie Ojeda, John Paradela, Marlene Lunghi Perez, Walt Peterson, Pinole Fire Department (Jim Brooks), Pinole Garden Club (Thelma McPherson and Pat York), Pinole Police Department (Paul Clancy and Pete Janke), Pinole Valley High School (Dan O'Shea, Steve Alameda, Ken Porto, Jim Erickson, Claire Wichelmann, and Jeff Wright), Marilyn Bennett Ponting, Margaret (Faria) Prather, Shirley Ramos, Linda Rosedahl, Jeff Rubin, Suzette Shaw, Celeste Silvas, Mary Simas, the Louis L. Stein Jr. collection, Geoff Torretta, the Union Pacific Railroad, George Vincent, Michael S. Williamson, and Mark Woodworth.

We also thank the sports media relations departments of the University of California at Berkeley (Chris DeConna), Fresno State University (Steve Schaack), the University of Missouri (Chad Moller), Oregon State University (Jason Amberg), St. Mary's College (Mandy Bible), Santa Clara University (Michelle Schmitt), and Stanford University (Jim Young) and these professional sports teams: Baltimore Ravens (Denver Parler), Chicago White Sox (Ray Garcia and Ron Vesely), Cincinnati Bengals (Jack Brennan and Jon Braude), and Cleveland Indians (Dan Mendlik and Bart Swain).

INTRODUCTION

Geography drives history. So it was with the growth of the township of Pinole. The appeal of the landscape has been a recurring theme of Pinole's history, beginning with indigenous peoples and continuing through time with a parade of migrants of diverse cultural backgrounds.

For instance, the desirability of the environment and plentiful natural resources had attracted a fairly dense Native American population prior to the coming of the Spanish in the 18th century. Then, too, it was the rich valley land that drew the Martinez family from the safety of San Jose to settle in the Pinole wilderness in 1837. W. R. Slocum, in his 1882 county history, favorably described Pinole as "the little hamlet on the pebbly beach of San Pablo Bay, situated at the mouth of the rich and beautiful valley by the same name." Slocum recognized in his early account that Pinole's proximity to the bay waters and fertile soil of the inland valley would be the twin geographic features motivating the small community's evolution.

Pinole holds the distinction of having one of the oldest names in Contra Costa County. Spaniards first explored the area during the 1772 Pedro Fages expedition. Fr. Juan Crespi penned the name in his diary, recording the Spanish word *penole* or *pinolli* for the meal made from seeds, grain, and acorns given to the explorers by the welcoming Native Americans. The name stuck to the area, so that when Don Ygnacio Martinez applied in 1823 for a land grant of almost 18,000 acres in the Contra Costa region, he requested the grant as El Pinole.

There were many families and individuals who helped shape the beginnings of Pinole in the 19th century. The earliest of these newcomers was the family of Don Ygnacio Martinez, who settled in the valley in 1837. Don Ygnacio named his holdings Rancho El Pinole and brought his wife, Maria Martina, and most of his 11 children to live in the large adobe home he had built there. They were called Californios, people of Spanish-speaking heritage but born in California. But the quiet pastoral life of the Californios was soon to end. The 1848 loss of California to the United States in the Mexican War and the subsequent Gold Rush led to the breakup of the rancho lands. This was a time of rapid growth and change for Pinole, highlighted by the Americanization of the open rancho lands to fenced farmlands.

Much of this change was due to the efforts of immigrants Dr. Samuel Tennent, an Englishman, and Bernardo Fernandez, a Portuguese sailor. They both began the nucleus of the new hamlet, but from different directions. In 1850, Tennent's wife, Rafaela Martinez, inherited the lucrative downtown and waterfront areas as her share of the Rancho El Pinole. They laid out the downtown area in lots and blocks, then sold and leased properties there and on the waterfront. Fernandez arrived in 1854 and later purchased the waterfront embarcadero from Tennent and called it Pinole Landing. Both men were entrepreneurs with a keen eye for business opportunities and saw Pinole's economic future as part of their own.

In 1865, the coming of the Martinez-to-San Pablo stage line through Pinole's Main Street enhanced commerce and population growth in the downtown. St. Joseph Church was erected in 1881. By 1886, a large one-room school was built in the center of Pinole. The population center

also changed to a central downtown with wooden-plank sidewalks surrounded by clapboard homes and horses. Pinole now had three distinct regions—a bustling downtown, the bay-front landing, and the farming hinterland in the valley.

The Northern Railway came to the waterfront in 1877, bringing new arrivals. The California Powder Works moved from San Francisco to Pinole and Hercules, providing jobs and new residents. In 1894, Pinole's first newspaper, the *Pinole Weekly Times*, made its debut.

By the turn of the 20th century, a thriving community had been born in the old downtown with businesses, hotels, churches, and numerous saloons. The San Francisco and San Joaquin Valley Railroad (later the Atchison, Topeka, and Santa Fe and then the Santa Fe) arrived in 1900. In 1903, Pinole voters met at Forester's Hall to vote on incorporation. The vote was 150 to 6 in favor, and the hamlet of Pinole was now a city. The new city's population was 665. By 1926, Pinole's first municipal building had been financed by the chamber of commerce to house the firehouse, library, jail, and council chambers. In the late 1950s, the chamber sponsored a contest for a slogan to promote Pinole. The chosen entry was "Pinole, the Sun-kissed Gem by the Bay." In 1958, the new Interstate 80 split the town from the valley, ushering in a period of rapid urbanization. Pinole was discovered by the outside world, and the valley ranch lands now grew subdivision homes instead of tomatoes.

By the 1960s, Pinole had lost much of its small-town atmosphere. There was a building boom that took away the oak-covered hills around town, and with them the family winter mushroom hunts as well. Many of Pinole's historic homes and buildings were razed. Population and business grew away from the old downtown. Residents now went by car instead of foot to outlying stores. Pinole Valley High School was built to accommodate the large influx of children.

The seven-member Pinole Historical and Museum Commission was organized in 1968 because of concerns that the community's past was being neglected. It was the forerunner of the Pinole Historical Society, which was formed in 1974. Later years have seen a more diverse and public-spirited population, as well as renewed interest in Pinole's heritage. The Fiesta del Pinole was held to recapture the spirit of the town's Hispanic heyday. A redevelopment agency was formed to restore the Old Town and revitalize the area. The Pinole Senior Center, Pinole Youth Center, and Pinole Community Theater for the Arts opened. In 2005, the Faria House, which first housed James Tennent's family in the 1880s, was relocated to the old downtown to, hopefully, become the city's first history museum.

The challenge of history is to recognize its time flow so we can better understand it. To understand history, we have to somehow bridge then and now and connect the dots of past events with the present. One way to do this is by learning to view the past not in terms of timelines or yesterdays, but rather as an ongoing present. This book attempts to do so by creating a visual tour of Pinole, that "Sun-kissed Gem by the Bay." This work is also a tribute to the many individuals who once captured images of Pinole in their viewfinders.

—George R. Vincent

One

PREHISTORY ERA
BEFORE 1772

Geographically, Pinole lies within what the Spanish called the Contra Costa, or "opposite coast" from San Francisco. Pinole sits on the San Pablo Bay shoreline among sheltered valleys and hills and is bisected by Pinole Creek. It was into this favorable environment that the California Indians settled about 3,000 years ago. The Spanish gave the name Costanoan, or "shore people," to the Native Americans who lived here. It is believed that up to 1,500 Native Americans lived in the area encompassing Pinole, San Pablo, Rodeo, and Crockett. The indigenous groups were called Ohlone, Huchuin, and Karquin.

The earliest inhabitants of Pinole left no records. Their existence is known through the descriptions given by early Spanish explorers and missionaries, as well as through archaeological evidence unearthed from their village sites. The native Pinoleans lived primarily on an acorn economy and food from the nearby bay. They left behind village shell mounds or refuse piles called "kitchen midden." The shellfish beds that provided so much of their diet would later attract Chinese clam diggers, who peddled their wares door to door in early Pinole.

The largest ancient village site was in the present downtown area. It extended an entire city block along today's San Pablo Avenue, including the current city hall complex. Early residents unknowingly built their homes on the dark, rich soil left behind by their native predecessors. The first Pinoleans lived in huts made of tule. Pinole Creek's fresh water and the surrounding hills and shoreline made an ideal setting for settlement and a plentiful food supply. Tule reed boats and tule decoys were used for fishing and hunting. The Buckeye tree provided another food source. The Native Americans also discovered how to use it as a "fish poison" to paralyze fish and make them float to the surface. The Native Americans in the Pinole area were peaceful and at first welcomed the Spanish. However, many Native Americans were forcefully removed to Mission Dolores at San Francisco to be converted to Christianity.

Most of the Native Americans were decimated by introduced diseases, and their culture was destroyed. The remainder became laborers and servants on the ranchos. The Martinez and Tennent families had Native American servants as late as the 1860s. The last mention of a local California Indian was in a late-19th-century news article. At that time, a Native American boy at the adobe ranch in Pinole was reputed to have shot an eagle with an 8-foot wingspan.

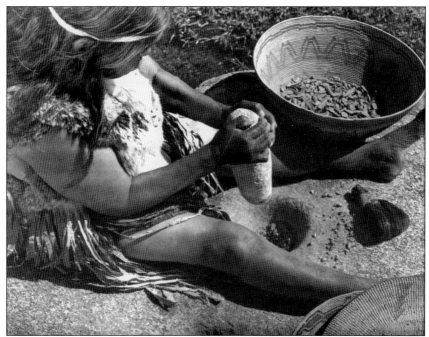

REENACTMENTS. These scenes are reenactments showing how Native Americans made mush, or pinolli. Arthur Barr took these photographs on the banks of the Kern River in 1954. Native American women gathered acorns that dropped from oak trees. The acorns were hulled and the kernels removed. Acorns were pounded with a stone in a mortar hole, as seen above. Hot water was poured over the meal to leach the bitter tannin from the acorn meals. The leached acorn meal was then ready to be consumed. It was eaten raw or dried or cooked to mush. The photograph below shows the meal made into small cakes that were baked on hot stones. (Both City of Pinole.)

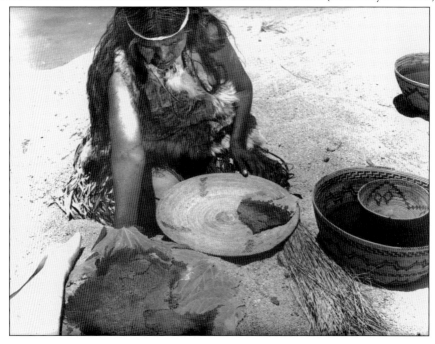

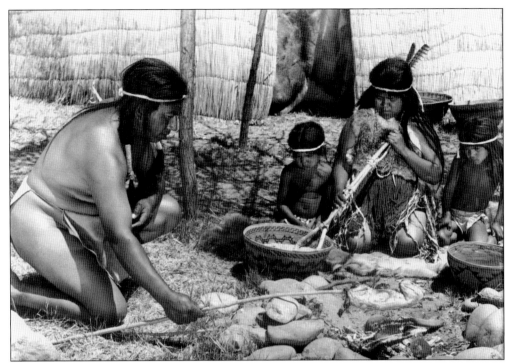

MAKING PINOLLI. The mush was also cooked in a basket over hot stones (above), stirred and lifted with a looped stick. Native Americans ate the mush by dipping their fingers into the cooking bowl (below). (Both City of Pinole.)

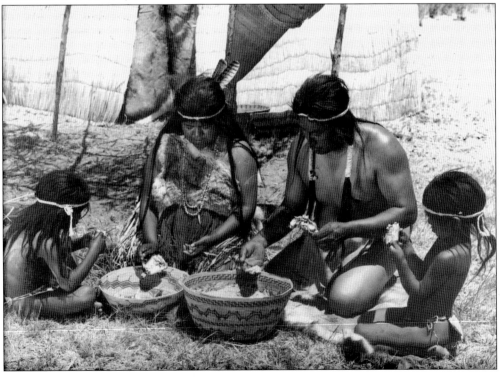

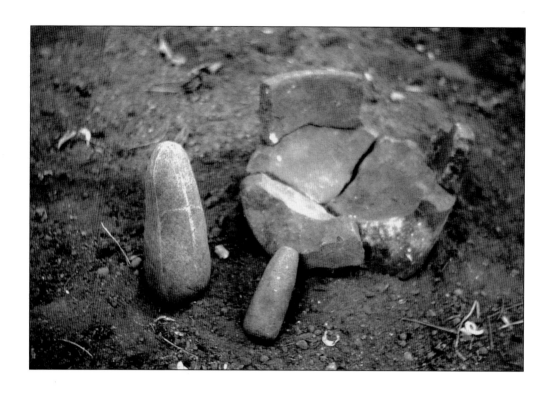

MORTAR AND PESTLE. The above items were dug up in the garden of Tony Barrocca, who lived downtown on San Pablo Avenue. The homes below were built on the largest Native American village site in Pinole, stretching from Tennent Avenue to Oak Ridge along San Pablo Avenue. (Both City of Pinole.)

Two

SPANISH/MEXICAN ERA
1772–1850

The first outside contact with the region gave Pinole Contra Costa's oldest name. In 1772, Pinole was first logged in the diary of Fr. Juan Crespi of the Pedro Fages Expedition. The Native Americans gave the Spanish a gift of a ground foodstuff made of acorns, seeds, and grain, which Father Crespi recorded as pinolli, an Aztec word for flour meal. The next Spaniards in the area were part of the 1776 Juan Batista de Anza expedition. Padre Pedro Font wrote of "a fair-sized Indian village on an arroyo (Pinole Creek) whose men and women were happy to see us."

In 1821, Mexico took control of California from Spain. In 1823, Ygnacio Martinez became the grantee of 17,786 acres stretching from San Pablo Bay to the Carquinez Strait. Martinez had been a dutiful soldier on the Spanish frontier for 42 years, most without pay. At first the rancho was called Nuestra Señora de la Merced and later Rancho El Pinole. At the time, Pinole Valley was described as a wild and desolate place with herds of deer and elk and numerous grizzly bear. The Martinez girls learned to rope grizzlies for sport from horseback.

By 1836, Martinez had built a large adobe home in the valley about 3 miles inland from the bay where he kept a large boat. Into this setting he brought his wife, Doña Maria Arellanes, and most of his 11 children. By 1839, he had thousands of cattle, horses, and sheep and an orchard and vineyard. Hides were taken by *carreta*, or ox cart, to Point Pinole and traded for supplies from Yankee ships. Martinez kept a brass cannon as protection from the threat of Native Americans. When his sons Jose and Vicente were married, he fired it in celebration. A week of festivities followed with feasting, dancing, horse racing, and bullfights. The sons built adobe homes next to their father. The cluster became known as Los Adobes of Pinole Viejo (old Pinole).

Martinez died in 1848 and was buried at Mission San Jose. The new township of Martinez, which incorporated in 1876, was named to honor the pioneer family. The Americanization of the landscape subsequently displaced the rancho culture. By 1907, the last occupants of the quake-damaged adobe were indigent descendants of Don Ygnacio Martinez. By this time, Martinez's grandson Ignacio Martinez, Ignacio's wife, Emma, and their daughter Ramona were the disadvantaged tenants of a new owner, Bernardo Fernandez. For years, Pinoleans made excursions to the adobe ranch ruins to picnic and have their pictures taken. Today only the limestone foundation lies buried in Pinole Valley as a reminder of Pinole's Hispanic beginnings.

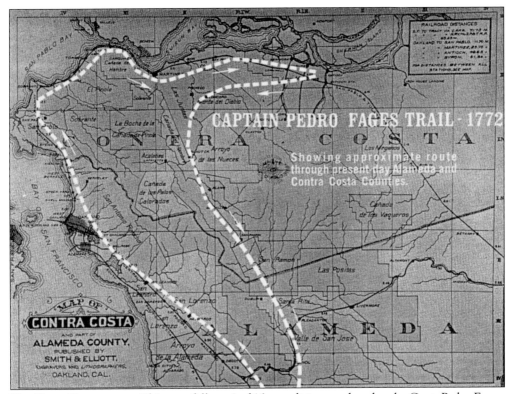

THE FAGES EXPEDITIONS. This map follows 1 of 16 expeditions undertaken by Capt. Pedro Fages, who marked the first exploration of Contra Costa County. (George Vincent.)

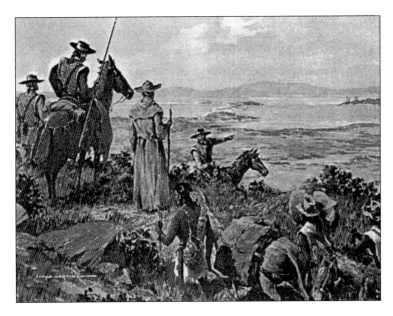

FR. JUAN CRESPI. Crespi gave the name pinolli to the food served by Native Americans to the exploration party. (George Vincent.)

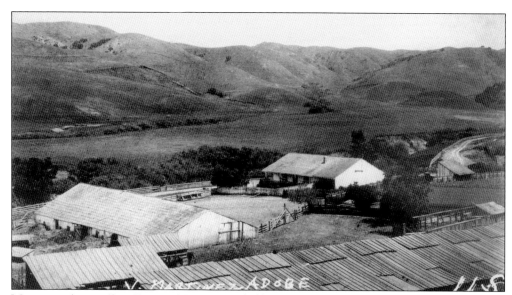

Martinez Adobe. Don Ygnacio Martinez settled his family in the Pinole Valley, seen here, in 1837 after receiving a grant of approximately 18,000 acres, when California was part of Mexico. He called his home Nuestra Señora de La Merced. Later it was named Rancho El Pinole. (Joseph Mariotti.)

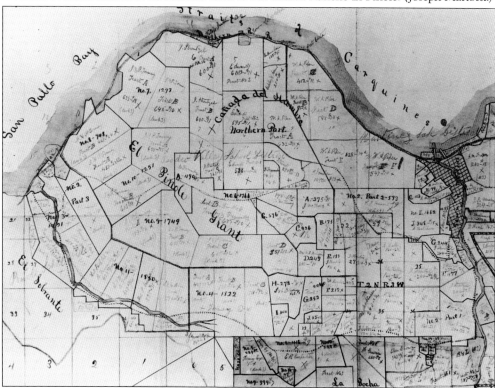

The El Pinole Grant. The grant stretched from San Pablo Bay to Cañada del Hambre (Valley of Hunger), including the township of Martinez. Martinez became Township No. 1 in Contra Costa County; Pinole became Township No. 11. By the 1870s, the 11 heirs of Don Ygnacio Martinez had sold most of the lands of El Rancho Pinole. (George Vincent.)

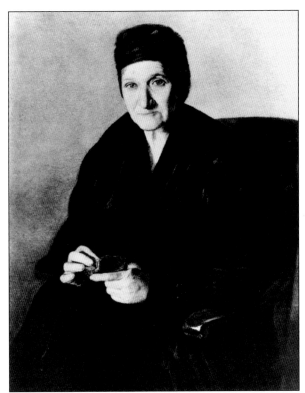

THE MARTINEZ FAMILY. Doña Maria Martina Arellanes Martinez (left) was the wife of Don Ygnacio Martinez. They were married in 1802. Don Ygnacio and Doña Maria had 11 children, two sons and nine daughters. Don Ygnacio died in 1848, and Doña Maria became a strict matriarch of the family. Legend has it that she whipped her son Vicente Jose (below) for marrying below his station. She lived at the family adobe until 1866 when it was lost for nonpayment of taxes. Vicente, the second son, was born in 1818. He was the grandfather of Ramona Martinez. He built the first adobe home in Cañada del Hambre, now the Alhambra Valley, in 1849. He lost it in 1852 to Edward Franklin, a land speculator from San Francisco, to pay a debt. The home still stands as part of the John Muir National Historic Site. (Both George Vincent.)

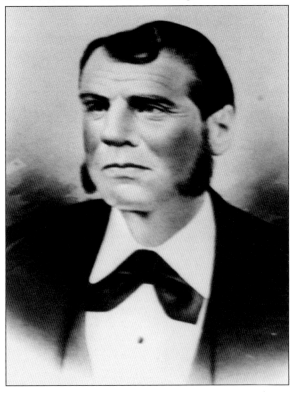

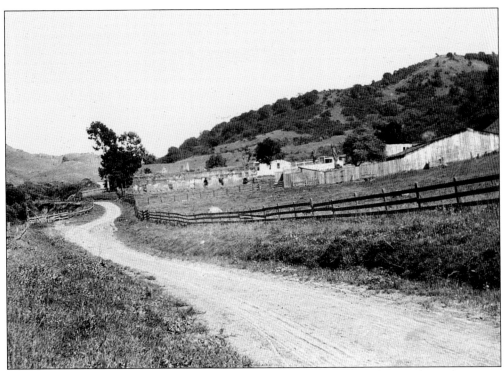

THE MARTINEZ ADOBES. The *c.* 1890 photograph above shows the Adobe Ranch Road running in front of the Martinez Adobes on the right, in what is now Pinole Valley Park. This view is facing east. Below are the ruins of the Martinez Adobes (Pinole Viejo) in a photograph taken in the 1920s. (Both George Vincent.)

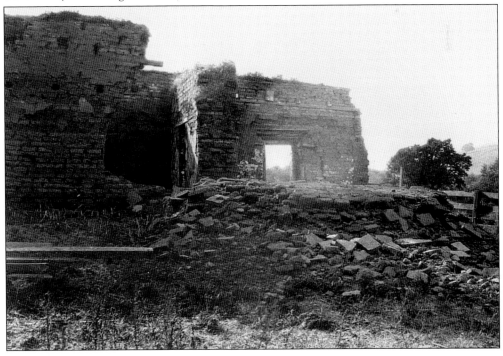

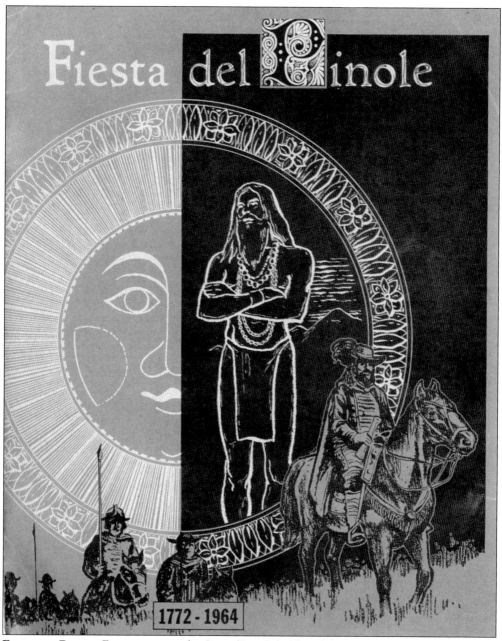

Fiesta del Pinole. For many years, the City of Pinole held a celebration commemorating Pinole's Hispanic roots. This cover of a celebration booklet shows the Capt. Pedro Fages expedition that explored Alta California in 1772. Fr. Juan Crespi kept a diary of the expedition; he recorded that the Native Americans in this area were fair-skinned and bearded, which explains the bearded Indian in this drawing. (George Vincent.)

Three

IMMIGRATION ERA
1850–1879

The year 1850 began a phase of rapid changes that led to Pinole's growth as a community. Rancho Pinole was divided among the Martinez heirs and the Gold Rush began, followed by statehood. The old order of the Californio pastoral life declined and disappeared with the Anglo invasion of the rancho lands. Cattle-dotted hillsides were replaced with farms and fences. Two of these new immigrants, Dr. Samuel Tennent and Bernardo Fernandez, pioneered Pinole's move in the direction of a township. Both were lured by gold but got no further than Pinole.

Dark-haired beauty Rafaela Martinez married Englishman Dr. Samuel Tennent in 1850. Their wedding party rode to Mission San Jose where there was a three-day fiesta. In 1851, the Tennents moved into Pinole's first wooden home, built with precut lumber from Maine. With them came their Native American servant girls, Louisa and Delphina. Their large ranch occupied the surroundings of present-day Collins School. They raised prized horses and had a racetrack by the bay. Rafaela's share of the rancho was the future downtown and waterfront properties, which they mapped and divided into blocks and lots. Pinole's side streets along Tennent Avenue—Plum, Pear, Prune, and Peach—were named for their orchards.

A sailor since age 13, Portuguese immigrant Bernardo Fernandez arrived in 1854. He partnered with Capt. Francis E. Cruz in his bay shipping business before becoming sole owner. By 1859, he had three schooners and had built wharves, warehouses, a store, and a house. His embarcadero was called Pinole Landing. That same year, he married Carlotta Cuadra at St. Mary's Church in San Francisco.

Fernandez eventually purchased the waterfront lands from Tennent. His last home, the 22-room Fernandez Mansion, was built in 1894. From the lighthouse-like cupola at the top, Fernandez watched his enterprise. Bernardo's son Manuel Fernandez served as Pinole's beloved doctor for 47 years.

By 1877, Fernandez had acquired most of the valley lands and ranches. He would supervise his holdings from his black buggy. He was remembered as a kind man who would give a child a dime and an orange for opening a gate but also as a strict businessman who wanted a penny owed to him. Both Tennent and Fernandez were also benefactors of their new hamlet, as well as its visionaries. Tennent donated land for the first downtown school in 1886. Fernandez supported the school, and the family gifted a site for a city park in the 1930s, as well as land for a waterfront sewage treatment plant in the 1950s.

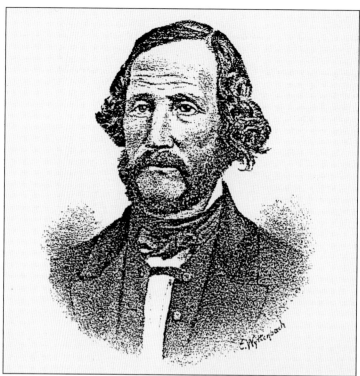

SAMUEL JOHNSON TENNENT. Tennent was one of Pinole's founders in the 1860s. He was personal physician to the king of the Sandwich Islands (Hawaii) and tax collector of the Port of Lahaina. He and Rafaela Martinez Tennent reared 10 children on their ranch south of what is downtown today. The Tennents owned all of what today is now Old Town and the Pinole waterfront. They mapped and laid out the town in blocks and lots. (City of Pinole.)

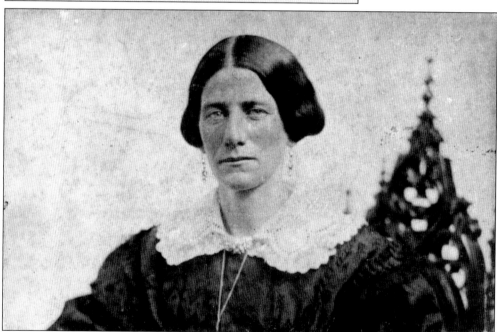

RAFAELA MARTINEZ TENNENT. Rafaela was the seventh child and one of nine daughters of Don Ygnacio and Doña Maria Martinez of El Rancho Pinole. She was born at the Presidio of San Francisco where her father was *comandante* of the fort. She died on August 5, 1868, at the age of 44. Her 1/11th inheritance of the old family rancho included all of present-day downtown Pinole and its entire bay front. (George Vincent.)

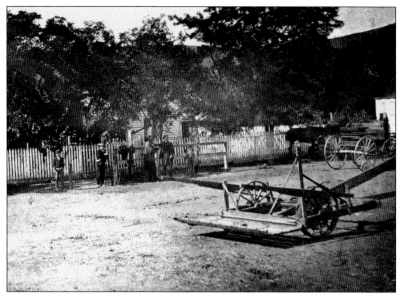

TENNENT RANCH HOME, 1860s. The ranch was settled in 1850 north of the present Interstate 80 and included today's Collins School site; its orchards extended to what is now Old Town. Pear, Plum, Peach, and Prune Streets are named for the fruits grown there. By 1870, Tennent had 2,500 acres of land valued at $50,000, producing 9,000 bushels of winter wheat, 2,400 bushels of barley, 250 pounds of butter, 8,000 pounds of cheese, and 150 tons of hay per year. Pictured above are, from left to right, Tennent's sons Augustus and James, John Bronsen (ranch foreman), and Samuel J. Tennent. The home pictured below was built by Tennent in 1850–1851 for his wife, Rafaela, and was Pinole's first wooden-frame structure. The pieces were cut, pieced, numbered, and ready to be assembled. The home was shipped from Maine around Cape Horn to Pinole. A bunkhouse in the back was Pinole's oldest standing building until razed in the 1990s. (Both George Vincent.)

SAMUEL J. TENNENT BRANDING IRON. The Tennent Ranch was known for raising fine horses. Tennent had a half-mile-long racetrack at the bay by the later Hercules Box Factory. The track attracted Sunday crowds from all around Pinole. Tennent kept a stable of 20 horses there. (Joseph Mariotti.)

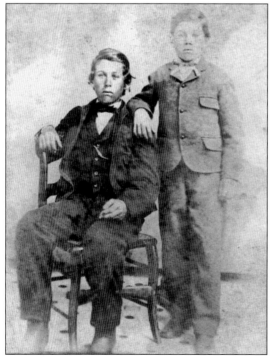

SAMUEL AND JAMES TENNENT. James and Samuel were two of the 10 children of Dr. Samuel and Rafaela Tennent. James (seated) was the eldest son. Samuel (standing) was killed at age 16 in a horseback-riding accident. James would marry in 1880 and build a two-story home across the street from his father's house for his new bride, Louise. This home later belonged to Joseph Dutra Faria and his wife, Maria Nunes Faria, and their children. (George Vincent.)

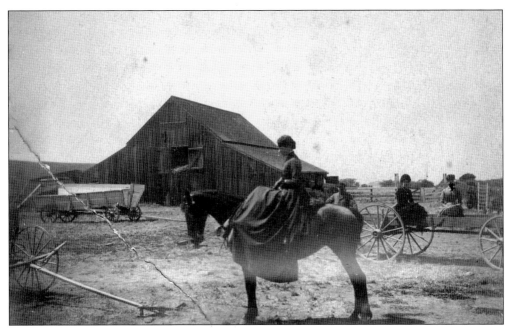

ANNA TENNENT BURNS ON HORSE, 1870s. The youngest daughter of Dr. Samuel and Rafaela Tennent, Anna was born in Pinole in 1865. She attended Pinole's one-room school on Fitzgerald Ranch and excelled in her studies. She rode by horseback to school daily and was an excellent rider. She died in 1949 in Berkeley at age 83. The old Tennent ranch barn stood as a town landmark near today's Margaret Collins School until it was torn down. (George Vincent.)

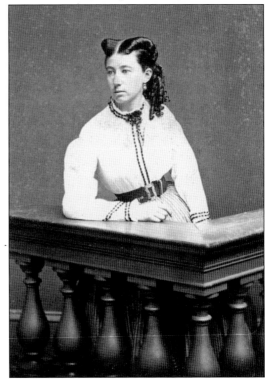

KATE TENNENT COUSINS, 1870s. Kate was one of the daughters of Dr. Samuel and Rafaela Tennent and the eldest of 10 children. She was an excellent horseback rider. Kate's home was on Tennent land near San Pablo Bay; it is now part of the City of Hercules. In 1881, she sold the family home, together with 9 acres of land, to newcomer C. H. Ellerhorst. (George Vincent.)

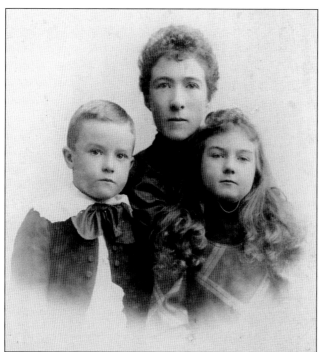

ANNA TENNENT BURNS WITH CHILDREN, 1890s. Anna married Thormen Burns, the first superintendent of the California Powder Works, which sat on land purchased from the Tennent family. She had two children: son Percy and daughter Kathyrn (Kittie). (George Vincent.)

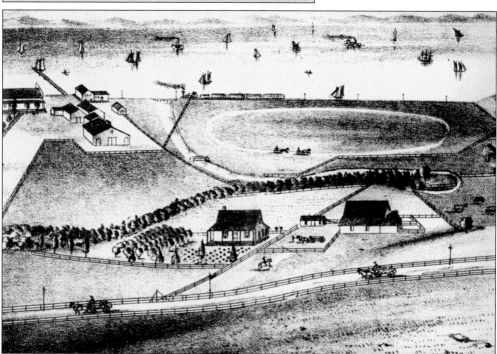

C. S. COUSINS RESIDENCE, 1870s. The 9-acre Cousins Ranch was on Tennent property north of the present-day Burlington Northern Santa Fe (BNSF) Railroad. The land and home were sold to the C. H. Ellerhorst family, and the house was remodeled in Spanish style. Frances Ellerhorst, beloved Pinole teacher and principal, was the last Ellerhorst to live in the home. She died in her late 90s in the 1970s. The home was purchased by the John McLeod family. (Joseph Mariotti.)

BERNARDO FERNANDEZ. Fernandez left Lisbon, Portugal, in 1840 at the age of 13 on a seagoing freighter. In 1854, he landed in Pinole and joined Manuel Sueyras in the shipping and trade business. Bernardo soon became the area's primary merchant and trader. Upon acquiring his first land at the waterfront from Rafaela Martinez Tennent's estate, he built a wharf, warehouses, and several homes. (Edward Armstrong.)

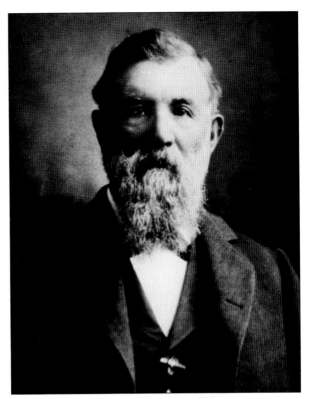

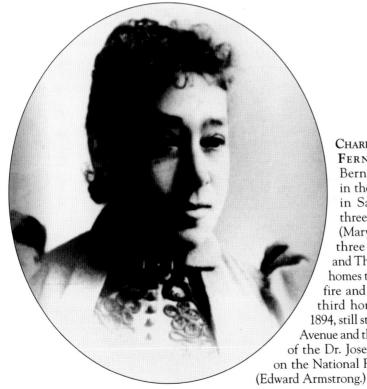

CHARLOTTE (CARLOTTA) CUADRA FERNANDEZ. She married Bernardo Fernandez in 1859 in the old St. Mary's Cathedral in San Francisco. They had three daughters, Maria Antonia (Mary), Anita, and Emelia, and three sons, Bernardo, Manuel, and Thomas. The first and second homes they built were destroyed by fire and flood, respectively. Their third home of 22 rooms, built in 1894, still stands at the foot of Tennent Avenue and the waterfront. It is the home of the Dr. Joseph Mariotti family and is on the National Register of Historic Places. (Edward Armstrong.)

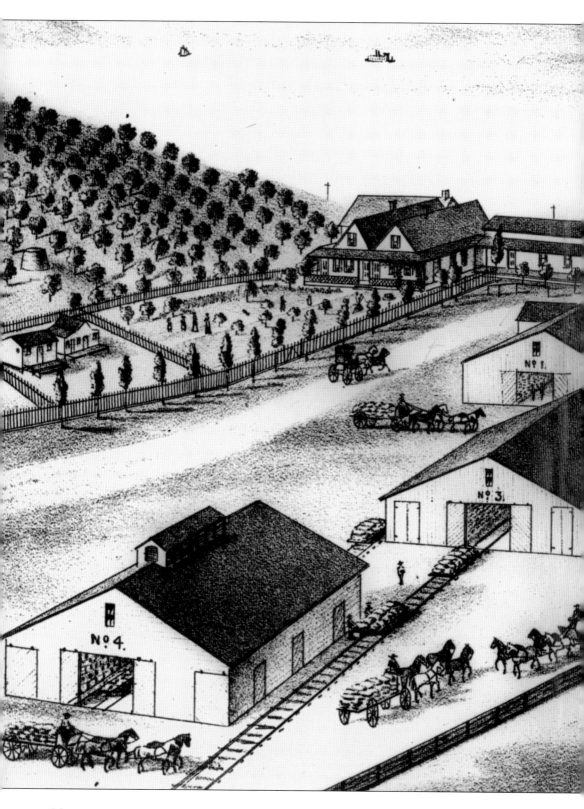

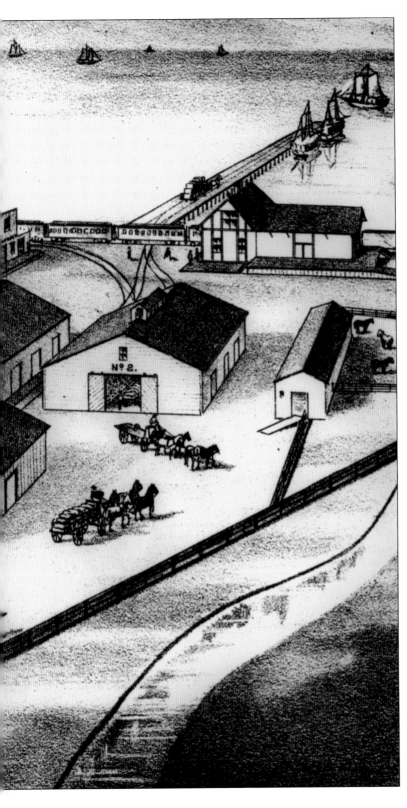

BERNARDO FERNANDEZ ESTATE. During the 1850s, Fernandez started a mercantile business on this site at the foot of Tennent Avenue. He built a supply store, constructed warehouses and wharves, hauled farm products, and handled the mail, becoming very instrumental in the early establishment of this city and Pinole's leading businessman. Dr. Joseph Mariotti lives with his family in the Fernandez Mansion today. A monument on the property states, "The site of Pinole's birthplace and the center of its activities until the early 20th century. The beginning of Pinole was built on the waterfront and around the mouth of Pinole Creek during the latter half of the 19th Century." (Edward Armstrong.)

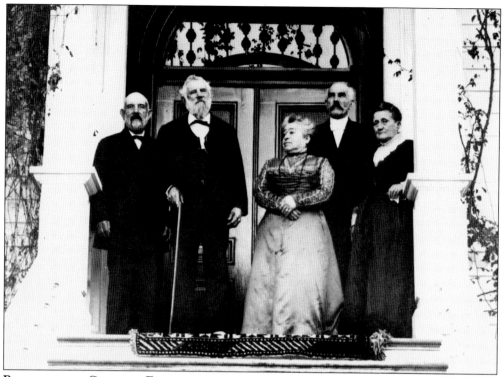

BERNARDO AND CARLOTTA FERNANDEZ AND GUESTS. Bernardo (with cane) and Carlotta (light dress) are shown here later in life, standing on the steps of the Fernandez Mansion with guests. Bernardo died on May 12, 1912. (Edward Armstrong.)

MARIA ANTONIA (MAMIE) FERNANDEZ, LEFT, AND HER SISTER, ANITA FERNANDEZ. They were the two eldest children of Bernardo and Carlotta Fernandez. The Fernandez girls first lived in their father's second home by the bay, built in 1862. It burned down in the early 1890s, and Fernandez built the 22-room Victorian mansion in 1894 where Mamie and Anita played and lived. (George Vincent.)

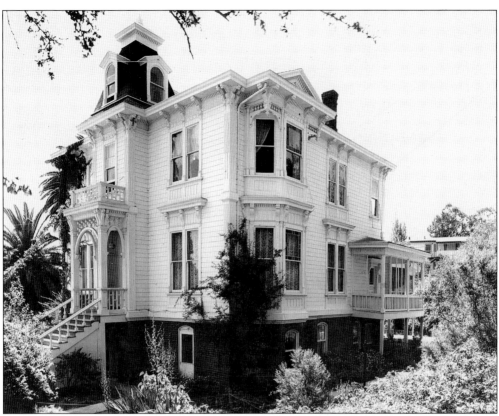

FERNANDEZ MANSION. The image above is a side view of Pinole's most historic home, one of two buildings in the city on the National Register of Historic Places. The other is the 1915 Bank of Pinole. At right, the Fernandez children play music in the family room. (Both Joseph Mariotti.)

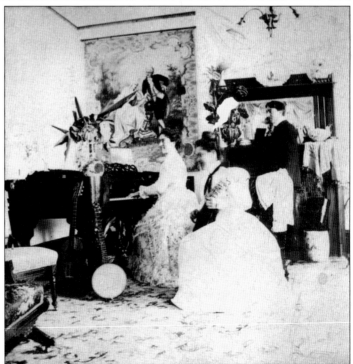

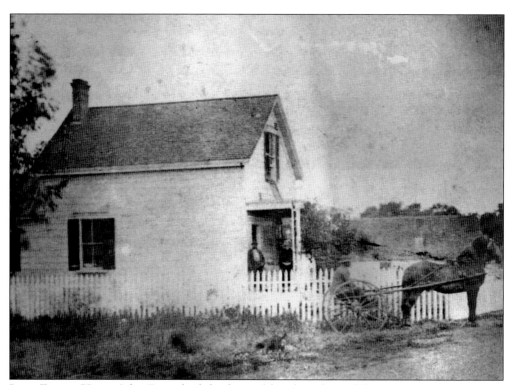

JOHN FRASER HOME. John Fraser built his home (above) in the middle of town on Main Street. It stood next to Manuel Marcos's Saloon (now the Bear Claw). The home was built for his new bride, Susie, the daughter of neighbor John Boyd. Fraser and Boyd ran the local blacksmith shop in the early 1900s. John Fraser had two sons, Harry and George, who were also blacksmiths. John Fraser was active in civic affairs and also served as town constable. In 1903, Fraser was one of the first members of the newly elected board of trustees of the now-incorporated City of Pinole. The home remained in Fraser hands until the 1950s (below) when it was torn down for the Pinole Plaza (now Park View Plaza) shopping center. (Both Joseph Mariotti.)

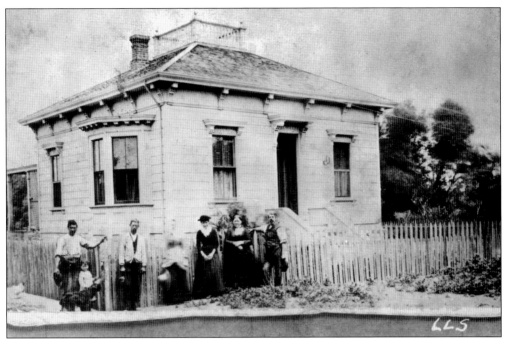

JOHN BOYD HOME. This home was built in 1874 at the edge of Pinole Creek and Main Street. Boyd, a blacksmith, lived there with his first wife, Katherine, and their daughter Susie; then with his second wife, Lucy, and Lucy's daughter. Lottie Race and her husband, George Pfeiffer, a Hercules carpenter, bought the house in the early 1900s. Pfeiffer remodeled the house into a Victorian home. Mrs. Pfeiffer moved to Pinole in 1898 at the age of 18 and lived in the home for 73 years. It was sold in 1979 and today houses the Pinole Creek Cafe. (Above, City of Pinole; below, Jeff Rubin.)

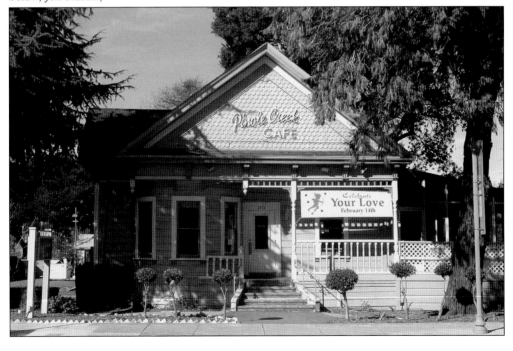

In all communications to this Department be careful to give the name of your Office, County, and State.

(CIRCULAR No. 1.) SERIES OF OCTOBER 15, 1876.

Post Office Department,

OFFICE OF THE FIRST ASSISTANT POSTMASTER GENERAL,

Washington, D. C. Aug. 29, 1878.

SIR:

The POSTMASTER GENERAL has established a Post Office by the name of *Pinole*, in the County of *Contra Costa* and State of *Cal.*, and appointed you POSTMASTER thereof, in which capacity you will be authorized to act, upon complying with the following requirements:

1st. To execute the inclosed bond, and cause it to be executed by two sufficient sureties, in the presence of suitable witnesses; the sufficiency of the sureties to be officially certified by a duly qualified magistrate.

2d. To take and subscribe the oath or affirmation of office inclosed, before a duly qualified magistrate, who will certify the same; also, to appoint an assistant, who must take the usual oath, to be returned with yours to me.

3d. To exhibit your bond and qualification, executed and certified as aforesaid, to the Postmaster of *San Pablo*, and then to deposit them in the mail addressed to me.

A mail key will be sent from the Mail Equipment Division. Blanks will be sent by the Blank Agency at Washington City, D. C.

After the receipt, at this Department, of your bond and qualification, duly executed and certified, and the approval of the same by the Postmaster General, a commission will be sent to you.

If you accept the appointment, the bond and oath must be executed and returned without delay. If you decline, notice thereof should be immediately given to this Office.

It will be your duty to continue in charge of the office, either personally or by an assistant, until you are relieved from it by the consent of the Department, which will be signified by the discontinuance of your office or by the appointment of your successor.

Respectfully, your obedient servant,

James A. Man
Acting First Assistant Postmaster General.

B. Fernandez, Esq.

N. B.—The quarters expire on the 31st March, 30th June, 30th September, and 31st December. Accounts must be rendered for each quarter within two days after its close.

Postmasters are not authorized to give credit for postage. Want of funds, therefore, is no excuse for failure of payment.

A Postmaster must not change the name by which his office is designated on the books of the Department without the order of the Postmaster General.

Be careful, in mailing letters and transient newspapers, to postmark each one, in all cases, with the name of your office and State; and, in all communications to the Department, to embrace in the date the name of your office, county, and State.

In stamping letters, great care should be observed to render the impression distinct and legible.

You are directed to inform the 1st Asst. P. M. General of the date you take possession of the Office.

POSTMASTER DOCUMENT. Pinole's first permit for a U.S. post office station was granted to Bernardo Fernandez in 1878. Fernandez carried the mail by ship to his wharf, Pinole Landing. Later the Southern Pacific depot served as the post office. In 1889, Edward M. Downer came to Pinole at age 19 and served as the first official postmaster. In 1910, the post office moved downtown near the Golden West Hotel on Tennent Avenue. Residents had their own private boxes inside. The current post office opened in 1960 and was built on the site of the Plaza School, which was torn down in 1933. From 1935 to 1968, Martin Collins served as Pinole's postmaster. (Contra Costa Historical Society.)

JOSEPH PFISTER RANCH, 1870s. It was a large ranch, running from the dirt roads called First Avenue (now Appian Way) and San Pablo Avenue, south to the present EBMUD reservoir near the former Doctors Hospital. In the 1860s and 1870s, central Pinole was surrounded by farms and ranches. (Joseph Mariotti.)

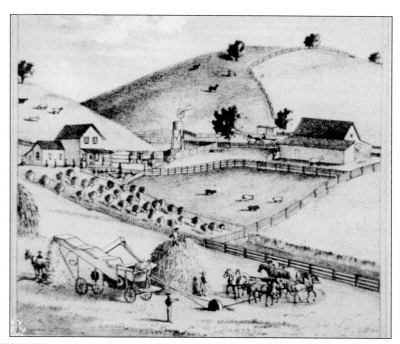

SCANLAN RANCH HOME. In 1870, Irish immigrants Michael and Penelope Scanlan purchased 335 acres along Pinole Creek plus 72 acres of the adjoining El Sobrante Grant for $7,000. The Scanlans raised 10 children here. Henry, the sixth child, born in 1861, was the last Scanlan to operate the ranch. In 1911, the ranch was sold to William Mohring, whose descendants work the ranch today. (George Vincent.)

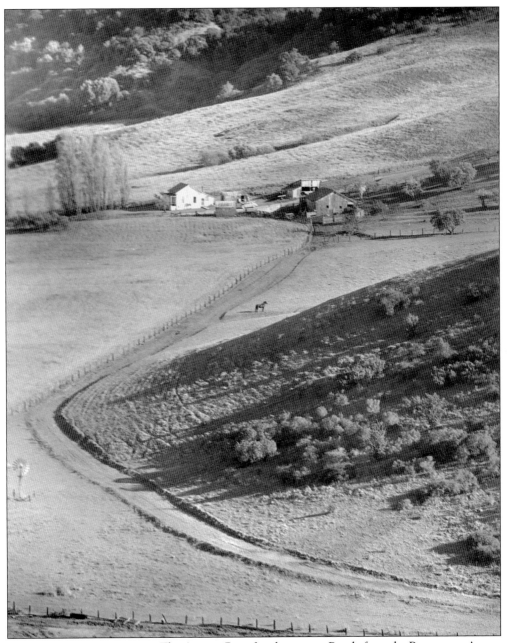

Rose Ranch, Pinole Valley. The Antone Rose family came to Pinole from the Portuguese Azores Islands during the great migration of the 1880s. They settled 1 mile west of the old Martinez Adobe Ranch on ranch land where Pinole Valley High School sits today. The high school opened in 1967. This photograph was taken in 1956 just prior to the land boom that transformed Pinole Valley into tract homes. The Rose Ranch and the Simas Ranch to the east were the last remaining glimpses of Pinole's ranch life in the valley hinterland. (Walt Peterson.)

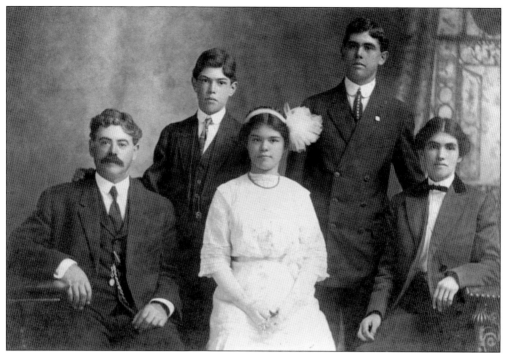

ROSE FAMILY. Pictured are, from left to right, Antone Rose Sr., Antone Rose Jr., Mary Agnes Rose (Faria), Manuel (Molly) Rose, and Florinda Perry Rose, wife of Antone Sr. Molly Rose was one of three children born at the Rose Ranch. He was a local butcher who made deliveries around town. He later partnered with Hokie Silva and Lowell Scroggins in a downtown butcher shop, on the corner of Valley Avenue and San Pablo Avenue, which later became a local landmark known as Chet Hall's Square Deal Garage. (Allen Faria.)

THE ANTONE ROSE RANCH. Antone Rose farmed and raised cattle on the west side of Pinole Valley Road, from the center of town out several miles into Pinole Valley. There were about 20 farms and ranches in the area, most operated by Portuguese immigrants. (Joseph Mariotti.)

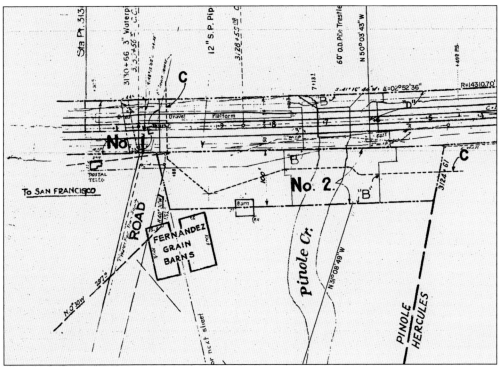

SOUTHERN PACIFIC MAP. The Southern Pacific Railroad (formerly the Northern Railway and now Union Pacific) came to the Pinole waterfront in the late 1870s. With the railroad came a Pinole depot with an agent and a post office. The new railroad provided many residents a route to San Francisco, where they bought five to six months of foodstuffs at Jim's Cash Store and shipped them back to Pinole. Because of the new railroad access and facilities, Chinese merchants came with their wares from San Francisco to Pinole homes and the California Powder Works moved here from San Francisco in 1879. The map above shows Union Pacific's land ownership along San Pablo Bay from the Bernardo Fernandez grain barns on the left to the Pinole-Hercules border on the right. Below is a record of railroad land purchases from some of the most prominent men and businesses of the era—Patrick and John Tormey, Bernardo Fernandez, Samuel J. Tennent, the Hercules Powder Company, and the California Powder Works. (Both Union Pacific Railroad/ Jack Meehan/City of Pinole.)

No	Grantor	Grantee	Instru.	Date	Record
1	Patrick Tormey	Northern Railway Co.	Grant Deed	Mch. 13, 1873	D.B. 25, 244, Sept. 16, 1873
	Patrick Tormey	" " "	Agreement	May 8, 1891	
	John Tormey	" " "	Grant Deed	Mch. 16, 1877	D.B. 32, 248, Mch. 22, 1877
	Bernardo Fernandez	" " "	" "	Feb. 20, 1877	D.B. 32, 119, Feb. 23, 1877
	Samuel J. Tennent	" " "	" "	Feb. 1, 1877	D.B. 32, 77, Feb. 15, 1877
	Samuel J. Tennent et al	" " "	" "	Feb. 1, 1877	
2	Bernardo Fernandez	" " "	" "	May 29, 1877	D.B. 32, 583, June 4, 1877
3	Hercules Powder Co.	Southern Pacific Co.	See Remarks	See Remarks	
4	" " "	" " "	Agreement	Mar. 20, 1914	
5	California Powder Wks.	" " "	Agfm. 2656.	June 2, 1906	
	" " "	" " "	Agfm. 2656	" " "	
Und. 1.	S.P.R.R.Co. et al (Def.)	Hercules Water Co. (Plt.)	Condemnation	Mar. 3, 1894	
Und·1	S.P.R.R.Co. & S.P.Co.	Hercules Powder Co.	Agreement	Mar. 1 1916	
" 5					
" 1	S.P.Co.	Town of Pinole	Easement	Feb. 7, 1956	
un 1,2	" "	Contra Costa Co. Fld. Ga. Dist.	"	May 28, 1965	
Un.1,2	S.P.Co.l City of Pinole &	" " " " "	"	Aug. 20, 1965	
Un. 1	S.P. Tptn. Co.	City of Pinole	"	Dec. 22, 1970	

Four

INDUSTRIAL ERA
1879–1918

Life in Pinole transformed into an emerging pattern of community spirit and energy. The hub of activity shifted to a central downtown supported by the waterfront commerce and the valley ranches. Wagons of hay and grain and cattle drives still came from the valley down Tennent Road to the bay. However, they now passed through a bustling, new downtown with wooden sidewalks, hotels, and saloons.

Pinole's first industry came in 1850. Manuel Sueryas, in his sloop *Citizen*, operated a small shipping business at Pinole's then-deep harbor. The coming of the Martinez-to-San Pablo stagecoach road in 1865 gave Pinole a commercial boost along Main Street. The roots of community developed in 1866 when Pinole's first one-room school opened at the Fitzgerald Ranch. A new cottage industry sprang up when Fernandez leased the shoreline to Chinese clam diggers, who built stilt homes.

The first large industry for Pinole was the California Powder Works. It located bayside after the Northern Railway (later Southern Pacific and now Union Pacific) arrived in 1879. The explosives industry and the railroad stimulated business and population growth, attracting immigrants from Portugal, Ireland, Italy, and Germany. Pinole now had a depot area for new arrivals and a post office. Walton's Livery provided horse-and-buggy taxi service. By the late 19th century, Pinole's commercial and cultural development was under way. The historic Four Corners was created where Tennent Avenue met San Pablo Avenue, sporting a saloon or hotel on each corner.

St. Joseph Church, the Plaza School, and Abraham Greenfield's Pinole Bazaar were erected downtown. Greenfield sold everything from clothes to coal oil, and he offered home delivery. Greenfield also had Pinole's first telephone number—"Pinole One."

John and Julia Collins arrived in Pinole in the late 19th century. They and their eight children lived above the family business, the Klondike Saloon, on Tennent Avenue. John served as constable of Township No. 11, which included Pinole. This pioneer family was active in civic, educational, and religious affairs. Francis Collins was a longtime city attorney and Martin Collins was postmaster for many years. Margaret Collins was a prominent educator and school superintendent; her sister Marie was a popular teacher.

Pinole greeted the new century by becoming a city in 1903 when 150 male citizens voted for incorporation. Edward M. Downer's Bank of Pinole and the Pinole-Hercules School District were formed in 1905. The imposing "School on the Hill" was built overlooking the new city, and by 1906 Pinole had its first downtown wooden-pipe sewer line.

By World War I, the Hercules Powder Company was the area's largest employer and a world supplier of explosives. Locals worked at the plant, braving deadly accidental explosions that rocked Pinole frequently. The Spanish influenza epidemic of 1918 found Pinole residents wearing gauze masks or facing jail.

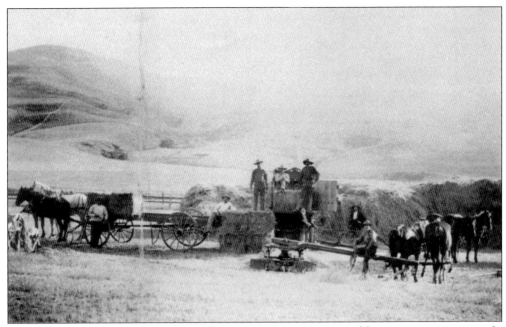

RANCHING IN PINOLE VALLEY. This photograph shows an Amend hay presser crew at work. Ranchers in the Pinole Valley would press hay into 250-pound bales by horse-powered presses and store them during the winter in Bernardo Fernandez's large warehouses near San Pablo Bay. They hoped to sell the hay for a profit the following winter, as it took many tons of hay to feed the horses used by farmers and construction companies. (Joseph Mariotti.)

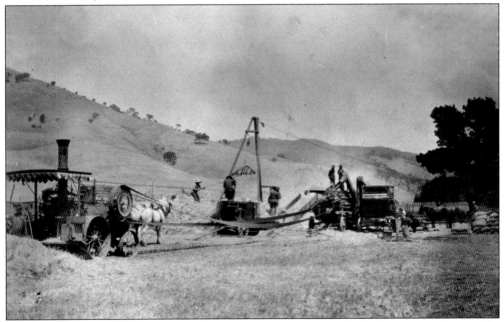

INDUSTRIAL PINOLE VALLEY. The Amend steam tractor worked the land in this 1920 photograph. Farmers, mostly Portuguese, worked the land from near downtown Pinole deep into Pinole Valley for about 6 miles, to the edge of Alhambra Valley. There were about 20 farms in the area. (Joseph Mariotti.)

THE FIRST SCHOOL. Pinole's first one-room school was located on the Fitzgerald Ranch along First Avenue, now Appian Way, and opened in 1866. The school was a farm building that stood until the 1950s and was used as a garage. (George Vincent.)

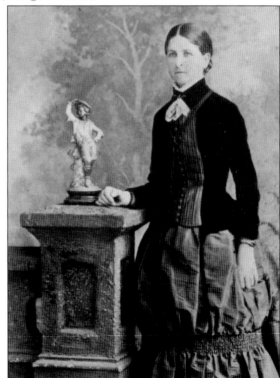

AN EARLY TEACHER. Mary Kelly taught at the school in 1884; she was the school's first female teacher. She taught all grades from first to eighth and was paid $65 a month. Manuel Fernandez, son of Bernardo Fernandez and later a doctor, was a seventh grader in her class. (Edward Armstrong.)

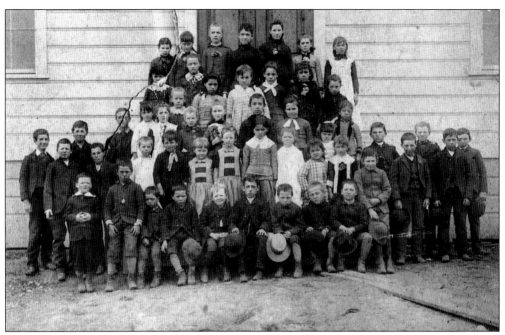

GRAMMAR SCHOOL. These children comprised the Plaza School class of 1889. The teacher was M. McHarry. The post office is on this site today. (Joseph Mariotti.)

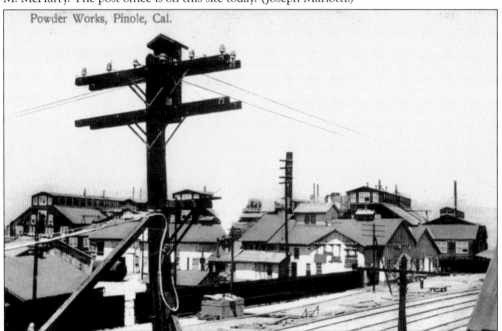

Powder Works, Pinole, Cal.

CALIFORNIA POWDER WORKS. In 1869, California Powder Works established a dynamite plant in San Francisco in the same area that is now Golden Gate Park. As San Francisco developed and the populace moved closer to the plant, the dangerous business of producing explosives proved undesirable, and California Powder Works was forced to find a new location. In 1879, California Powder Works began purchasing land on the isolated shores of San Pablo Bay. The plant was constructed in two years and finally, in 1881, began producing dynamite. (Joseph Mariotti.)

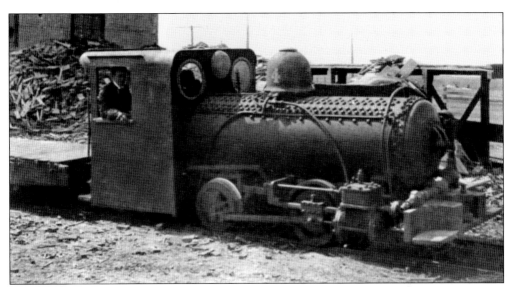

PORTER MACHINE. This "fireless" locomotive was used at the powder works where fire, sparks, and heat were avoided in the dangerous environment. High-pressure steam was charged into a "boiler," and it ran until nearly empty, returning for recharging at the power plant. The potent and explosive black powder made by the California Powder Works was called Hercules, after the Greek mythological hero known for his strength, in order to signify how powerful the black powder was. What began as a California Powder Works plant site on the shores of San Pablo Bay grew into the company town of Hercules, which incorporated in 1900. (Joseph Mariotti.)

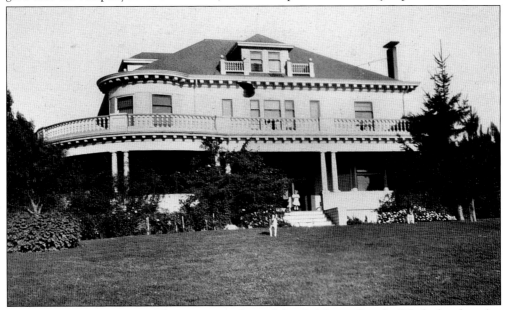

SUPERINTENDENT'S HOUSE. The superintendent of the California Powder Works lived in this mansion. Before the U.S. government declared war on Germany, the Hercules plant produced dynamite and TNT (trinitrotoluene) for the Allied forces in World War I. In 1915, the plant manufactured 20,000 pounds of explosives daily. After the United States entered the war in 1917, the plant manufactured more than 7 million pounds of TNT per month, making California Powder Works the largest-producing explosives plant in the country. (Joseph Mariotti.)

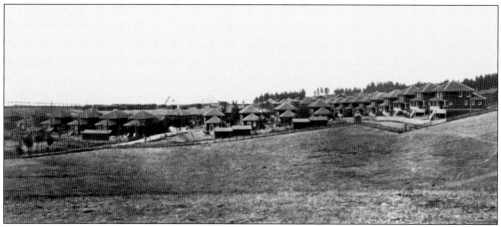

WORKERS' HOUSING. Workers from all over the area were employed at the powder works, one of the region's largest employers. Many employees, who came from out of the area, including other states, were housed in cottages built by the powder works expressly for them. (Joseph Mariotti.)

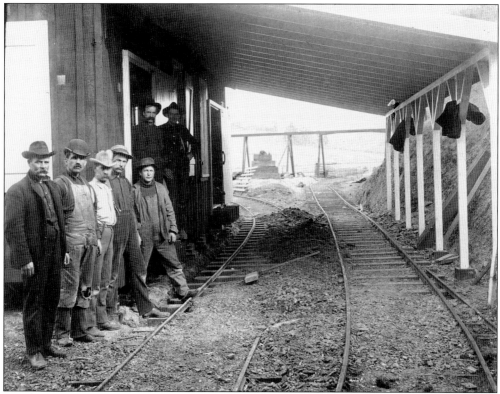

POWDER WORKS WORKERS. Working at the powder plant was dangerous and occasionally deadly. On May 22, 1895, the nitroglycerin house of the California Powder Works was destroyed by an explosion, which killed 14 workers. Every person around the mills was thrown down to the ground by the tremendous force of the explosion. Huge trees were thrown half a mile into San Pablo Bay. Nitroglycerin tanks weighing a ton apiece were found 500 yards from the explosion site. From 1881 until 1919, fifty-nine lives were lost to explosions. (Joseph Mariotti.)

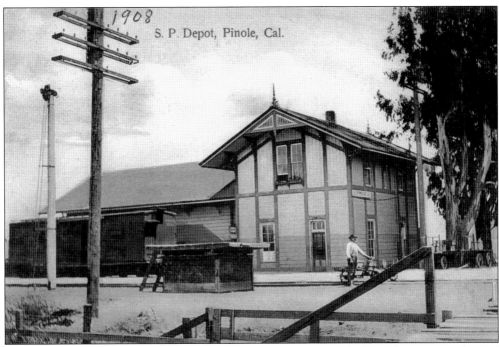

SOUTHERN PACIFIC DEPOT. Pinole's Southern Pacific depot was built in the 1880s at the end of Tennent Avenue. Southern Pacific's depots were always painted yellow and had a palm tree planted beside them. This depot, by the shores of San Pablo Bay, was demolished in 1958. (Joseph Mariotti.)

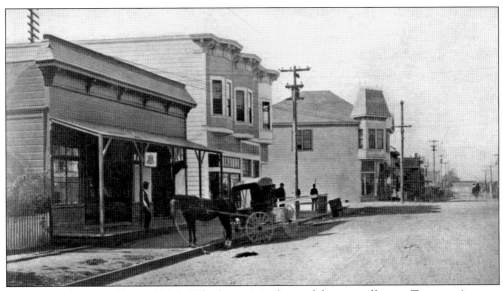

DOWNTOWN PINOLE, EARLY 1900s. The horse is in front of the post office on Tennent Avenue. This view is looking north, across San Pablo Avenue, toward San Pablo Bay. Note the couple in the horse and carriage at the far right proceeding down Tennent Avenue toward the Santa Fe train trestle and the bay. The building with the cupola in the middle is today's Antlers Tavern. (Sonny Jackson.)

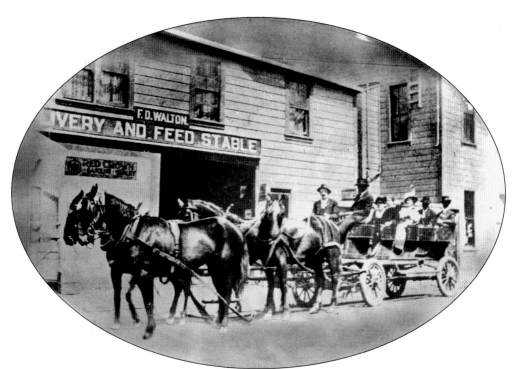

WALTON LIVERY AND FEED STABLE. This was the first taxi service in Pinole and was located on Tennent Avenue between San Pablo Avenue and Fernandez Park. The park was not developed until the 1930s and was a gift to the city from Dr. Manuel Fernandez, son of Bernardo and Carlotta Fernandez and longtime doctor at the powder works. (Above, Shirley Ramos; below, Don and Ida Castro.)

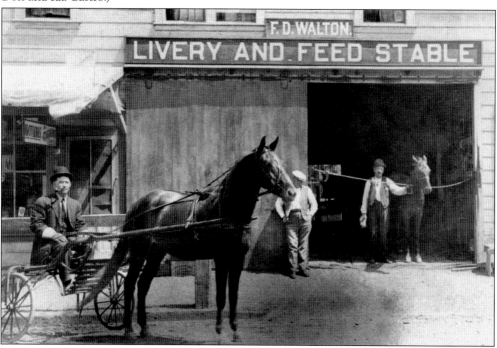

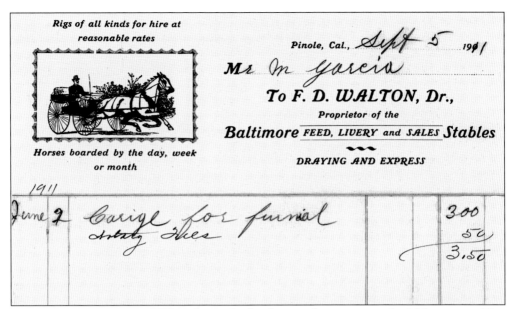

1911

June 2	*Carige for funral*			3 00
	dirty thes			5¢
				3.50

WALTON LIVERY INVOICE. Walton Livery had a thriving business into the 20th century. This September 5, 1911, invoice to Mr. Garcia is for a carriage for a funeral. (George Vincent.)

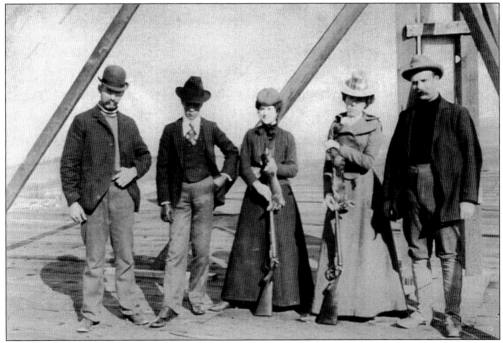

THE OLD RESERVOIR ON THE HILL WEST OF PINOLE, 1900. Pinoleans spent time hunting in the hills around town as well as fishing and hunting duck in the creek and bay. The women are Stacia Dean (left), a teacher and principal at Rodeo School, and Mary Lewis, a member of one of Pinole's first Portuguese families. Mary Lewis's brother Bill founded the Pinole Municipal Band, and her brother Manuel ran the Swenson and Lewis Tavern in 1910. Mary Lewis married John Vincent, and they lived behind the First and Last Chance Saloon on Tennent Avenue where John ran the bar. (George Vincent.)

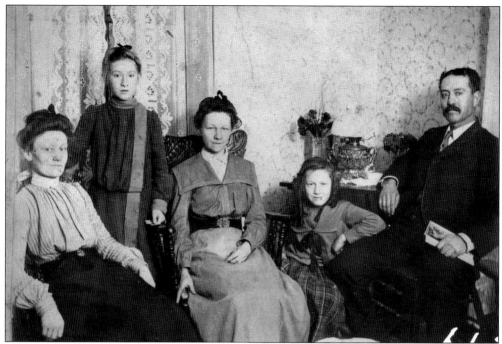

HIGUERA FAMILY. Pictured here from left to right are Matilda Hathaway Higuera, Eva Higuera (Boone), Lucy Higuera (née Hathaway), Kittie Higuera, and Pete Higuera, a descendant of an early area rancho family that married into the family of Don Ygnacio Martinez. Pete Higuera lived in the 1920s on Samuel Street and Pinole Valley Road with his wife, Lucy. His home later became the rectory for St. Joseph Church. (George Vincent.)

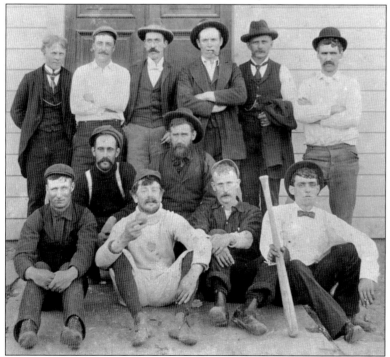

EARLY BASEBALL TEAM. By the beginning of the 20th century, baseball had become a popular sport in Pinole. The city had a team as far back as 1898, with games between neighboring towns offering people enjoyment on the weekends. (Joseph Mariotti.)

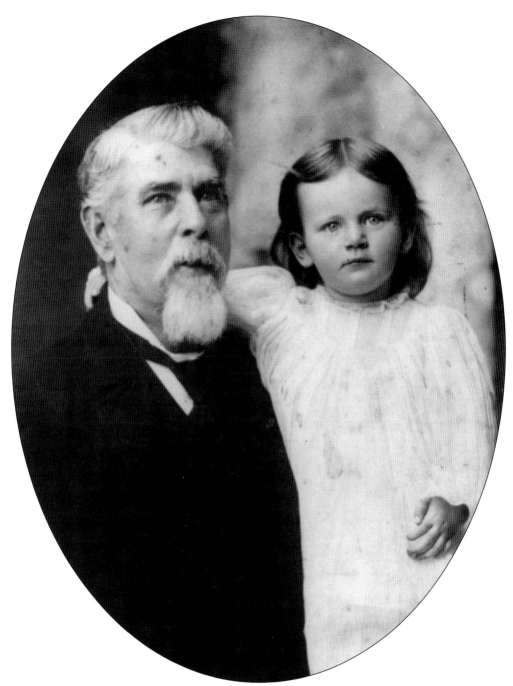

John Boyd Sr. Boyd came to Pinole during the 1870s and built his home downtown next to Pinole Creek and San Pablo Avenue (then Main Street). He lived there with his first wife, Katherine, and their daughter Susie; and then with his second wife, Lucy, and her daughter, pictured here. John Fraser had come to Pinole before the end of the 19th century. He married John Boyd's daughter Susie, who lived in the home built in 1874. John Boyd and John Fraser ran the local blacksmith shop in downtown Pinole, which was located between the Fraser and Boyd homes. (Joseph Mariotti.)

TENNENT AVENUE, 1900. In this photograph looking south, taken from approximately where the Santa Fe train trestle is today, the Commercial Hotel, owned by Manuel Marcos, is visible on the left. Note the horse and carriage in the middle of the road and a lone person walking toward the bay. (George Vincent.)

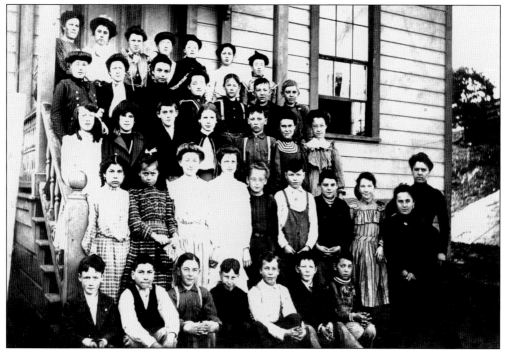

PLAZA SCHOOL, CLASS OF 1904. The teacher at the far right is Frances Ellerhorst, who spent her entire adult life as teacher and principal in Pinole. Ellerhorst School in Pinole Valley is named after her. (George Vincent.)

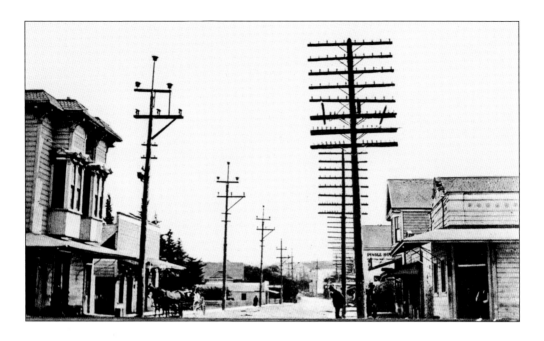

DOWNTOWN PINOLE, C. 1900. Above, a lone pedestrian prepares to cross Main Street, then a dirt road, at the intersection of Tennent Avenue and Main Street during the horse-and-buggy days of the fledgling city. In the photograph below, the Pinole-Hercules School No. 1 is visible at the top right, and the Downer Mansion is at the top left. The school opened in 1906. The intersection in the foreground is Quinan Street and Main Street. In 1906, Edward M. Downer Sr. and other businessmen of Pinole developed the Pinole Light and Power Company. With the help of the Hercules Powder Company, electric lights were brought to Pinole. Water was supplied to the city, again with the help of the powder company, and was piped to residents of Pinole and Hercules from a reservoir built in Pinole. (Both Joseph Mariotti.)

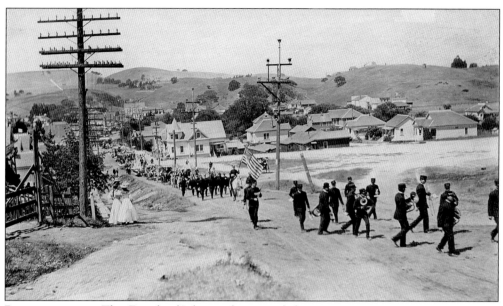

PARADE, C. 1900. This Fourth of July parade proceeded east up Main Street toward Hercules. The procession turned into the Santa Fe train depot, around where the Captain's Cottage is today. (Joseph Mariotti.)

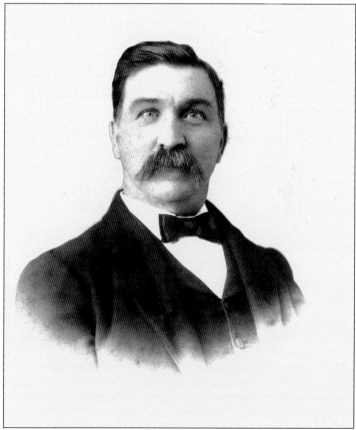

JOHN A. FRASER. John Fraser married Susie Boyd, the daughter of John Boyd. The two Johns ran the blacksmith shop that sat between their homes. John A. Fraser was the father of George and Harry Fraser, who followed their father into the blacksmith trade. (Joseph Mariotti.)

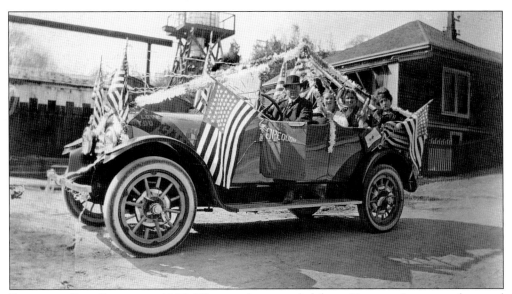

FOURTH OF JULY PARADE, C. 1912. The parade proceeded down Tennent Avenue and crossed Main Street (San Pablo Avenue). This was the parade route for many decades. William O'Kerland, the grandfather of Marilyn Bennett Ponting, is at the wheel. (Marilyn Bennett Ponting/Joseph Mariotti.)

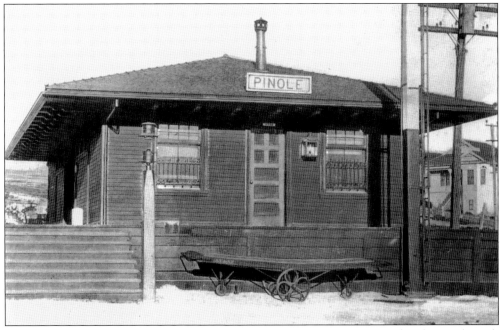

ORIGINAL SANTA FE DEPOT. In 1900, the Atchison, Topeka, and Santa Fe Railroad came through Pinole south of the Southern Pacific and built a red train depot at the northeast corner of Charles Street. It burned down in 1944. The next Santa Fe depot, built in 1945, was demolished by the railroad in 1998. (Joseph Mariotti.)

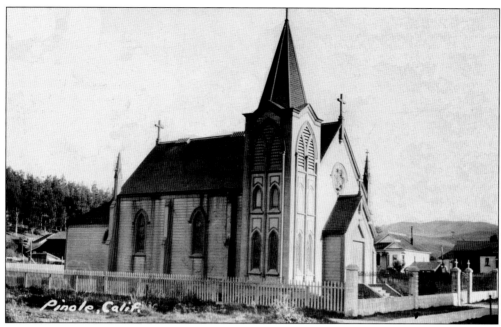

ST. JOSEPH CHURCH. The first Catholic church in Pinole was a wooden building used by people and bees alike. It was well known for a story about the bees that made their hives in the walls of the church. This church was built in 1881. (Susan Fernandez.)

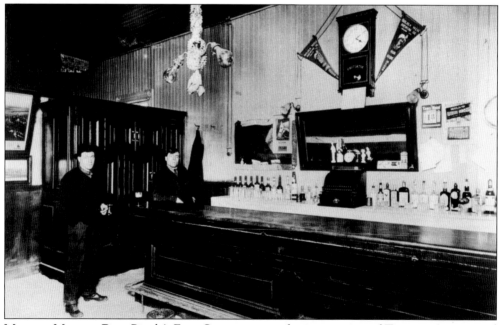

MANUEL MARCOS BAR. Pinole's Four Corners area—the intersection of Tennent Avenue and Main Street—featured bars and/or hotels on each of its corners. This is the Manuel Marcos bar on Main Street. Today it is the Bear Claw. (Margaret Prather.)

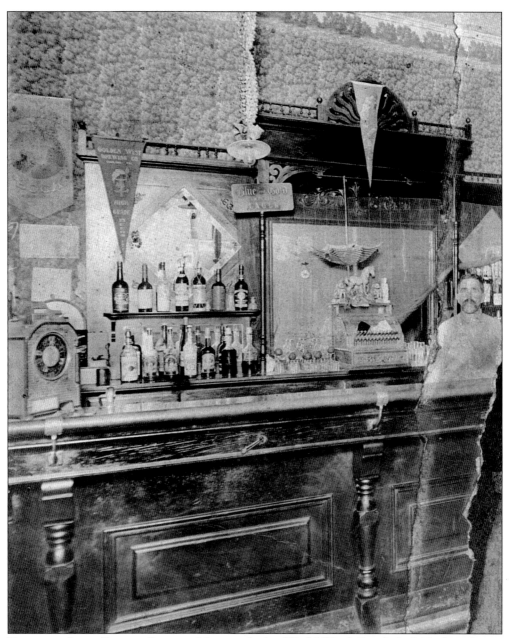

First and Last Chance Saloon. Up to and after World War I, Pinole had 13-plus saloons, with spittoons and sawdust-covered floors and all doing a brisk business. Pinole's many hotels and rooming houses boarded single men who worked at the Hercules Powder Company and spent their wages in Pinole's taverns. Jimmy Silvas's Golden West Hotel was on the southwest corner of Tennent and San Pablo Avenues. Across the street, north of San Pablo, was the Swenson and Lewis Saloon, later the Antlers Tavern, owned by Jack Silva. Further down Tennent, next to the Forester's Hall (later the opera house), was John Collins's Klondike Saloon. The last saloon on Tennent was the First and Last Chance, run by John and Charles Vincent. It was called so because it was the first saloon people came to when entering Pinole from the Southern Pacific depot and the last saloon for a drink before leaving town on the train. (George Vincent.)

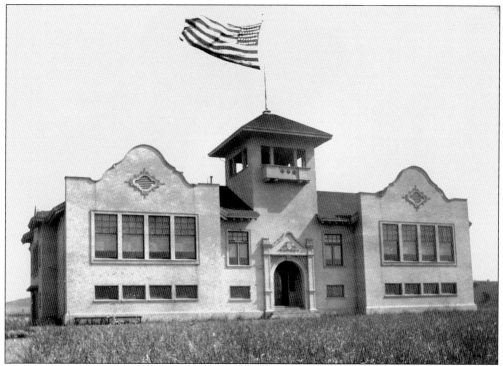

Pinole-Hercules School. Built in 1905–1906, it was known as the "School on the Hill." It served Pinole's and Hercules's children for more than five decades. It was razed in 1968. Frances Ellerhorst, Pinole's most esteemed educator, was the school's principal, shepherding thousands of students through its halls. (Edward Downer III.)

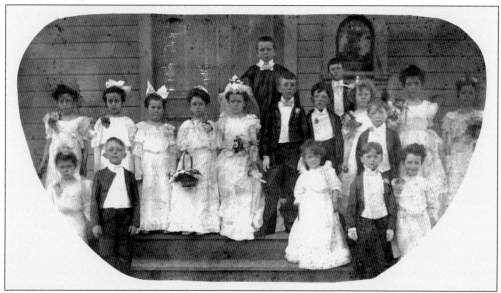

Tom Thumb Wedding. These mock weddings were all the rage 100 years ago. In this photograph, Ernest Woods is the minister; Arthur Hamilton, the groom; and Vera Gerrish, the bride. Others include Clifford Hughes, the best man, and Hazel Downer, daughter of E. M. Downer Sr., on the far right at the bottom. (Joseph Mariotti.)

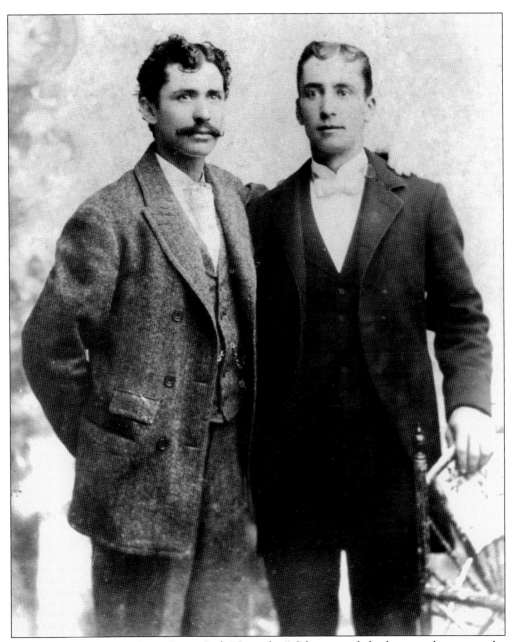

BROTHERS FRANK AND JACK SILVA. Jack "Squeaker" Silva owned the bar now known as the Antlers Tavern and lived upstairs in the early 1900s. Many early Pinoleans had nicknames. Jack was nicknamed Squeaker because that is how his voice sounded when he talked. He was an avid collector of animal trophy heads. He had a bear head, a moose head, a mountain lion on display, and a full-length deer in the tavern window facing San Pablo Avenue. He had a barn and stable on Tennent Avenue where he kept and rode his prized white stallion, much to the dismay of Eagles Hall dancers next door when odors from the stable floated through the windows. The Pinole Youth Center is now located on the site. (Margaret Prather.)

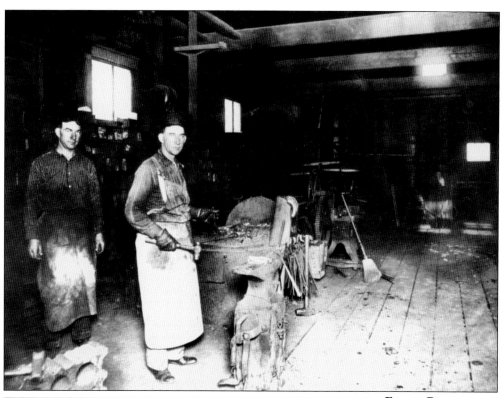

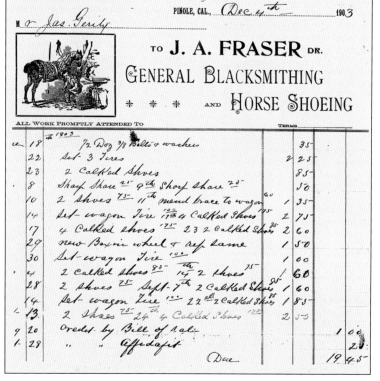

FRASER BLACKSMITH SHOP. George and Harry Fraser were the sons of John Fraser, who co-owned a blacksmith shop with his father-in-law, John Boyd. (Both Joseph Mariotti.)

Geo. W. Fraser

(Incumbent)

CANDIDATE FOR

CONSTABLE

11th Township—Pinole, Hercules, Rodeo

Contra Costa County

Primary Election Tuesday, August 27, 1918 4

ELECTION, 1918. George Fraser, already the incumbent, ran as a candidate for constable of the 11th Township of Contra Costa County, which included Pinole, Hercules, and Rodeo, in the 1918 primary election. (Margaret Prather.)

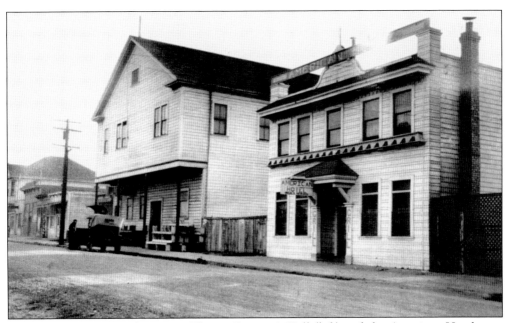

FORESTER'S HALL AND AMERICAN HOTEL. Forester's Hall (left) and the American Hotel were in the middle of the block on Tennent Avenue, between Main and Park Streets. Forester's Hall burned in 1908, and the Pinole Opera House was built soon after. In 1931, the opera house burned down. (Geoff Torretta.)

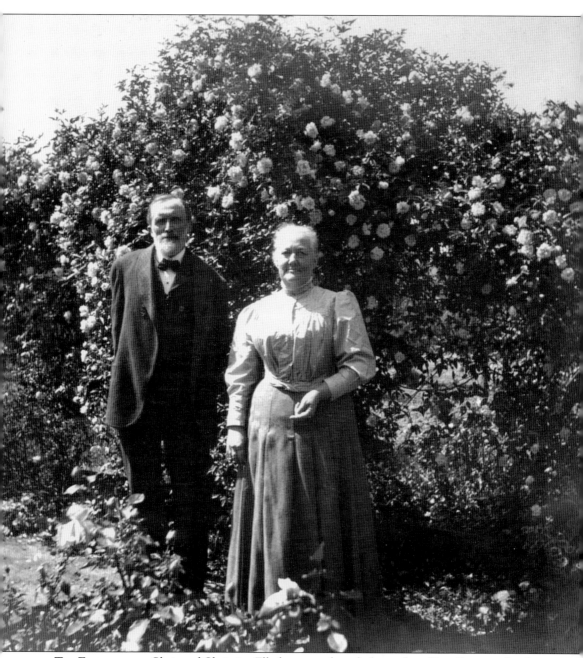

THE ELLERHORSTS. Chris and Christina Ellerhorst purchased a home from Kate Cousins, daughter of Dr. Samuel and Rafaela Tennent, in 1880. The Ellerhorsts had six children: Annie, Dora, Alice, Emma, Frances (Pansy), and Henry. (Edward Downer III.)

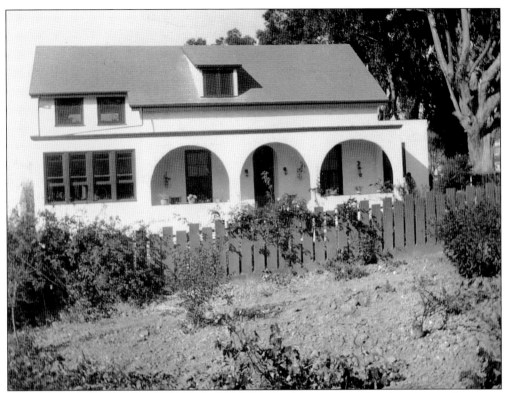

THE C. H. ELLERHORST HOME. Frances Ellerhorst was the last of her family to live in the home. This house, now owned by the McLeod family, is in Hercules across the train tracks from the site of the former Santa Fe depot. (Joseph Mariotti.)

ELLERHORST CHILDREN. Pictured here from left to right are the six Ellerhorst children, none of whom married: Annie, Dora, Alice, Frances (Pansy), Emma, and Henry. (Joseph Mariotti.)

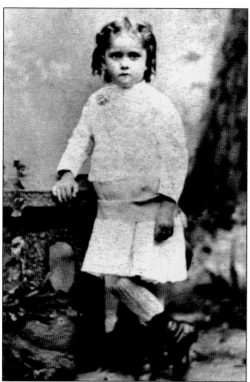

FRANCES L. ELLERHORST. Frances posed for this portrait at age four in 1878. She began teaching at the Sheldon School in 1895 at the age of 21. She taught in Pinole schools and was principal for 40 years at the Pinole-Hercules School No. 1, the "School on the Hill." She retired in 1940. (George Vincent.)

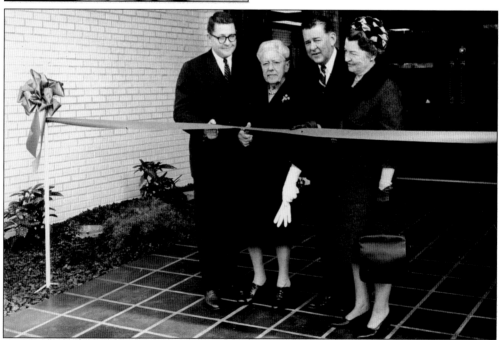

RIBBON CUTTING. On January 3, 1966, Frances Ellerhorst (second from left) cut the ribbon to open the downtown Pinole office of Mechanics Bank. Also in the photograph are, from left to right, Edward M. Downer III, Edward M. Downer Jr., and Hazel Downer Thornton. (Barbara Cronin/Mechanics Bank.)

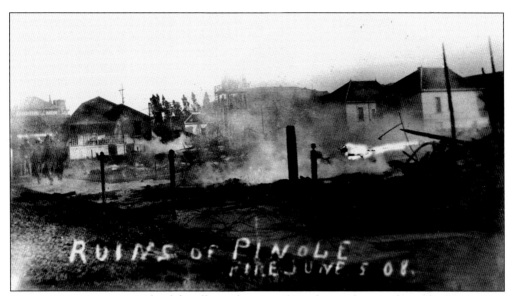

PINOLE UP IN SMOKE. Much of the all-wooden city of Pinole was destroyed in a devastating fire on June 5, 1908. Forester's Hall is smoldering in the foreground. The hall was the social center of Pinole, with lodge meetings, dances, and stage plays. The city's fire service then consisted of a hose cart pulled by volunteers. (George Vincent.)

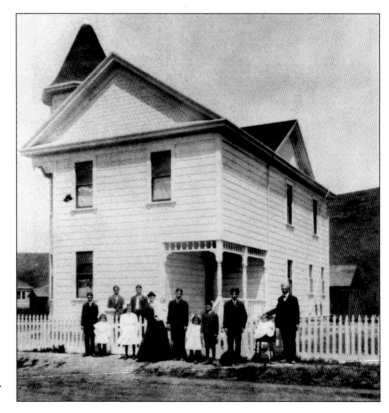

FIRST FARIA HOUSE. The Farias were one of the first farming families in Pinole. They moved here in 1893 and built this home at 1235 Pinole Valley Road in 1907. Joseph Dutra Faria and Maria Nunes Faria had 18 children, 11 who survived into adulthood. The home still stands, though it has been completely remodeled. (Margaret Prather.)

Joseph Dutra Faria. Joseph was born in the Azores in 1848. He came to New York in 1864 at age 16, sailed to Panama, went across the isthmus by stage, and came up the West Coast by boat to San Francisco. Joseph was a rancher, but after moving to Pinole he worked for the Hercules Powder Company for 19 years, including 11.5 years without a day off. After retiring, he resumed his farming. A U.S. citizen since age 21 (1869), he never missed a presidential vote. He was the scion of one of the most prominent Portuguese families in Pinole. He died in 1945 at age 97. (Edward Armstrong.)

Maria Nunes Faria. Maria was also from the Azores. She married Joseph in the old San Pablo Church in 1885. They celebrated their 60th wedding anniversary on January 25, 1945. Maria ran the family farm with her sons while Joseph worked at the Hercules Powder Company. Maria died in 1946. (Edward Armstrong.)

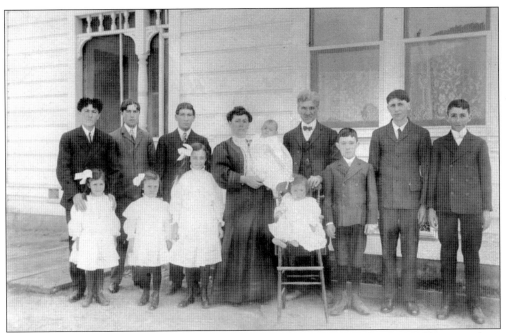

FARIA FAMILY. Descendants of Joseph and Maria Faria still live in Pinole. Pictured here are, from left to right, (first row) Angeline, Isabel, Mary, Maria, baby Edward, Anni (in high chair), and Louis; (second row) Manuel, Joseph, Antone, Joseph, Fran, and William. (Margaret Prather.)

THE HOUSE ON THE HILL. Three generations of Farias lived in what was the former James Tennent home, where the Kaiser Permanente Medical Office Building stands today. The Faria House was relocated to Heritage Park in downtown Pinole in 2005 and is being preserved as a historical landmark. (Margaret Prather.)

FARIA HOUSE AND TENNENT BARN. This photograph, taken in the 1950s, shows the Faria House (left) and the barn on the former Tennent Ranch. (Walt Peterson.)

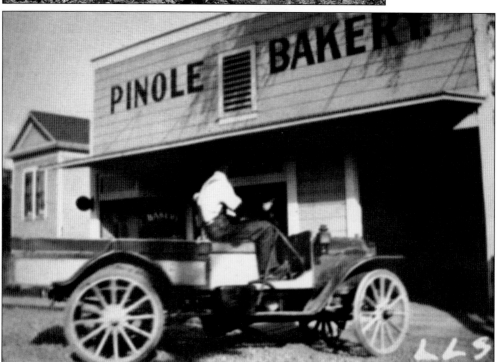

PINOLE BAKERY. J. B. Downer, brother of E. M. Downer, sold the Pinole Bakery to the T. W. Woy family. Newcomers here from Pennsylvania, the Woys expanded into the grocery business in 1906 and had the first auto delivery. Their home (left) is on the southwest corner of San Pablo and Valley Avenues, next to the store. The house still stands. The bakery was the Top Café in the 1960s and is a State Farm insurance agency today. (City of Pinole.)

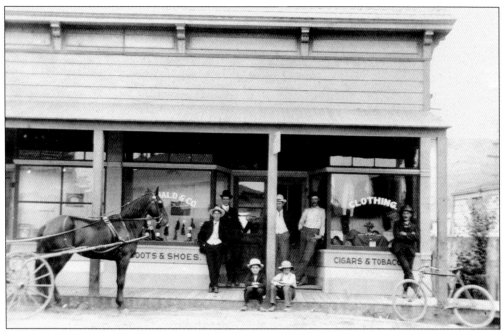

McDonald's and Company Clothing. Brothers Arthur (Jerry) and Fred McDonald operated this men's clothing store on Tennent Avenue in downtown Pinole. Arthur became constable of the township but was killed by machine gun when the Bank of Pinole branch in Rodeo was robbed in 1929. (Both Joseph Mariotti.)

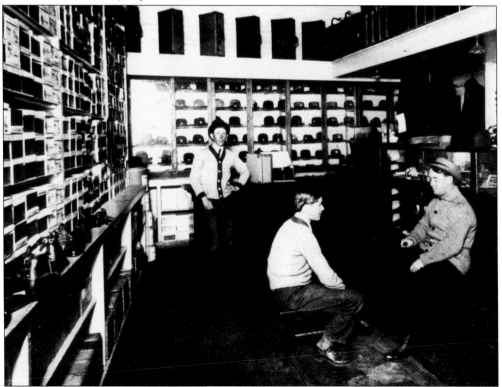

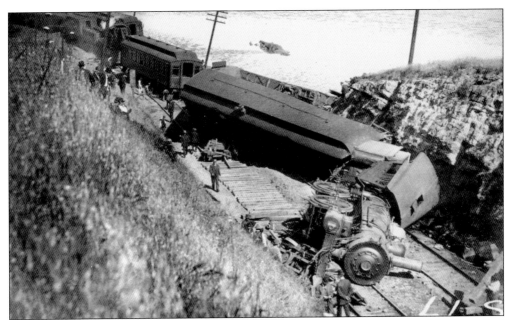

SOUTHERN PACIFIC TRAIN WRECK. On May 19, 1908, the SP's Oregon Express train No. 16 crashed at the foot of what is now Pinole Shores Drive. Three coaches left the track, and the engine, baggage, and express cars left the track and overturned. A small, rocky knoll saved the engine from going into San Pablo Bay. Five people were killed. (Joseph Mariotti/Louis L. Stein Jr.)

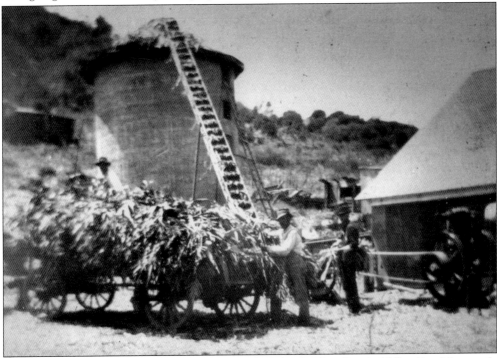

MOHRING RANCH. The Mohring family has worked this land on Pinole Valley Road for nearly 100 years, beginning with William Mohring in 1911 and continuing with his son Henry and grandson Leonard. (Joseph Mariotti.)

VILLALOVOS HOME. In the 1950s, the Villalovos family lived on the edge of Pinole Creek where it enters the bay. Jose Villalovos was a kind, Spanish-speaking widower with six children. He worked on the SP railroad and rented from the Fernandez family. A plank sidewalk lay across the marsh to his house. The home had an outhouse and was a patchwork of salvaged materials. Jose was a hard worker who helped fishermen and duck hunters launch their boats. (Margaret Prather.)

BRANDT COTTAGES. Along the east side of Pinole Creek, down Valley Avenue at the foot of School Hill, are the six Brandt cottages. Caroline S. Brandt owned the land and commissioned a local builder to construct these six cottages in 1906. Pinole has preserved many of its homes from the turn of the 20th century. (City of Pinole.)

TENNENT/CESELINI PROPERTY. These buildings were across the street from the Faria House (now Kaiser Permanente). It was part of El Rancho Pinole and was the 1/11th of the rancho inherited by Rafaela Martinez after Don Ygnacio's death in 1848. She married Samuel J. Tennent in 1849 and a year later they returned to the site and built the first frame home in Pinole. The ranch and orchard extended into present-day Pinole, with the large barn used for storing bales of hay needed to feed their many horses and livestock in the winter. The bunkhouse behind the home and slaughterhouse remained with the barn into the 1980s. Tennent's descendants sold the property in the early 20th century and the original house was taken down. The ranch was a dairy for the Joe Silva family. Jimmy Ceselini married Silva's daughter Albertina, and a Spanish-style home was built in the 1920s. (Margaret Prather.)

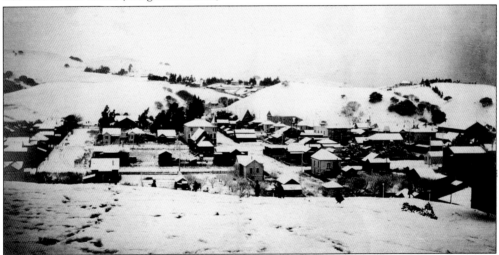

SNOW IN PINOLE! A storm in 1913 blanketed the young city in snow, giving residents of all ages an opportunity to revel in winter fun usually reserved for people in the Sierra Mountains and locations east. (George Vincent.)

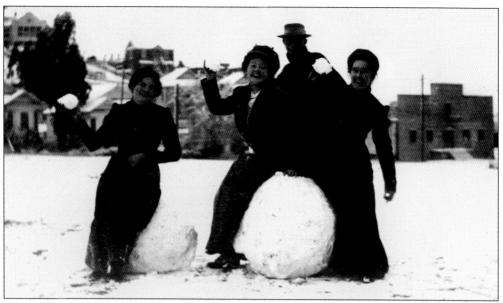

WATCH OUT! Pinoleans raced out to play in the snow after a winter storm covered the city in 1913. (George Vincent.)

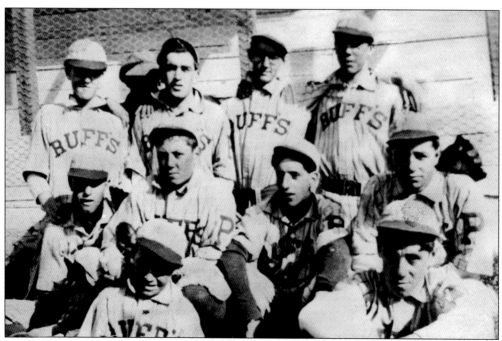

RUFF'S BASEBALL TEAM. On August 9, 1911, Ruff's Federals defeated the San Pablo Juniors 5-4 in a Sunday game at the Hercules diamond. The Federals were behind in the ninth inning 4-2 and loaded the bases. First baseman George Vincent (far right, standing) tripled and drove in the winning runs. (George Vincent.)

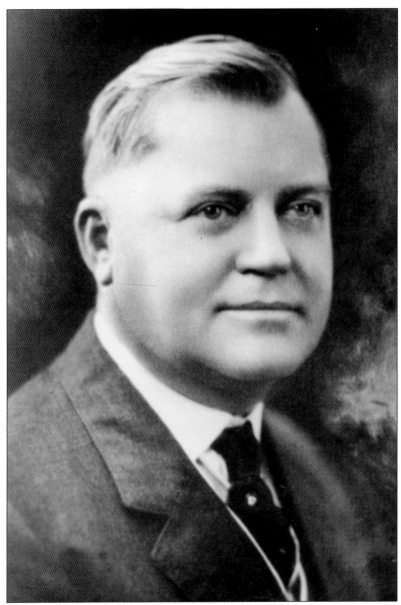

E. M. DOWNER. From 1889 to 1938, Edward M. Downer Sr. was among the most influential and prominent business figures in the history of Pinole and its surrounding communities. He served as the first official postmaster and was transfer agent and telegrapher of the Southern Pacific's Pinole depot. With a friend, he began publishing the *Pinole Weekly Times*, the town's first newspaper. When Pinole incorporated in 1903, he was its city clerk. In 1905, with a small floor safe in a one-room office, he opened the Bank of Pinole. There were no other banks in the area. He built the Bank of Pinole building on Main Street. He was elected to the city council in 1910. In 1913, he was elected mayor, a position he held until his death in 1938. In 1915, he became the second vice president of Mechanics Bank, and in 1919 he purchased controlling interest and became its president. His son E. M. Downer Jr. ran the Mechanics Bank for 40 years until his death in December 1978. Edward M. Downer III, the founder's grandson, is now Mechanics Bank's chairman of the board. (Mechanics Bank.)

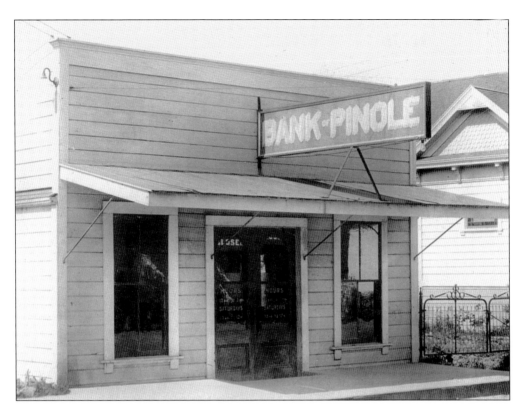

BANK OF PINOLE. The original Bank of Pinole (above) opened in 1905 and was the only bank in the city. The 1915 building (below) is on the National Register of Historic Places and survived the 1989 Loma Prieta earthquake. The buildings surrounding it did not and had to be torn down. (Both Joseph Mariotti.)

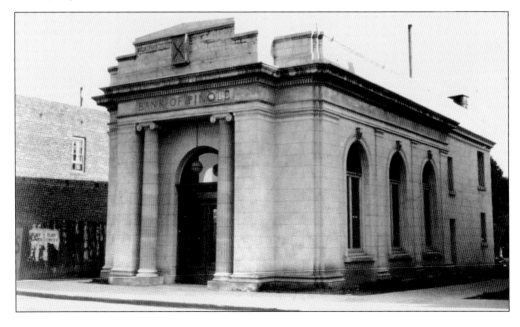

THOMAS W. HUTCHISON. In 1906, Thomas W. Hutchison became timekeeper of the California Powder Works, and in 1909 he accepted a position as assistant cashier at the Bank of Pinole. He was the first president of the Pinole Chamber of Commerce, which was founded in 1925. He raised money for the civic building, which included the library, firehouse, jail, and city council meeting room. He was treasurer of the City of Pinole for many years and secretary-treasurer of the Pinole-Hercules Methodist Episcopal Church where he raised money for its construction in 1925. He died in 1943. (Joseph Mariotti.)

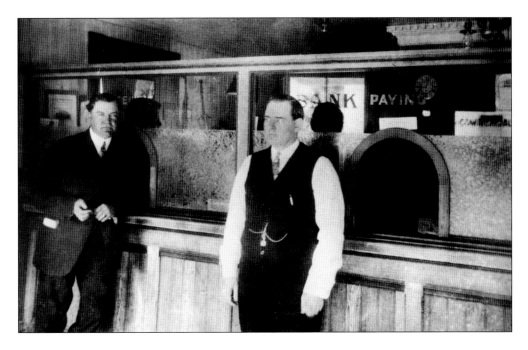

BANK OF PINOLE. In the above photograph, the bank's founder, Edward M. Downer Sr., is on the left and assistant cashier Thomas W. Hutchison is on the right. They are standing in the second Bank of Pinole building, which opened in 1915. The handsome interior of the Bank of Pinole is shown below. (Both Joseph Mariotti.)

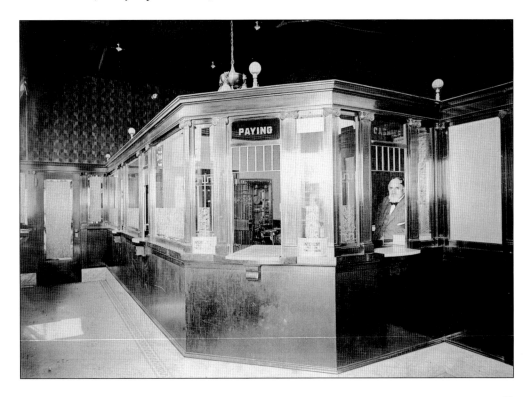

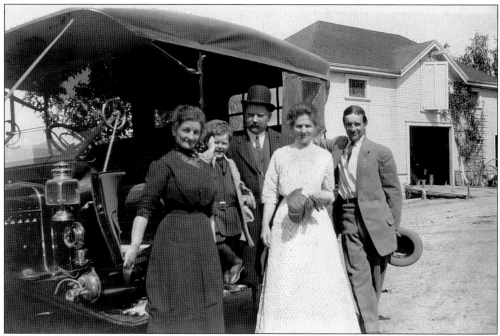

THE DOWNER FAMILY AND HOME. Next to Edward Downer's automobile (above) are Tracy (Bouquet) Gates, Edward M. Downer Jr., Edward M. Downer Sr., Elizabeth Bouquet Poinsett Downer, and Howard Poinsett, Elizabeth Downer's son from her first marriage. Elizabeth was a widow when she married Edward M. Downer in 1895. The Downer Mansion (below) was built in 1900 and remains a private home to this day. (Both Joseph Mariotti.)

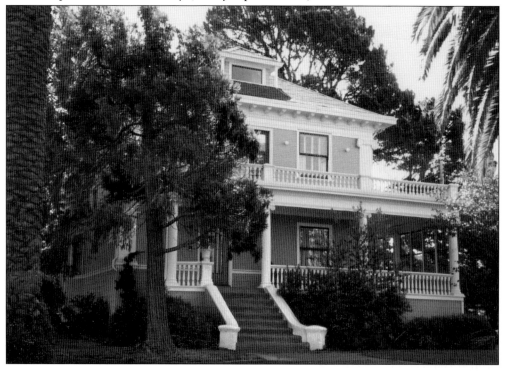

Rinks Theater. The theater was located on San Pablo Avenue between Fernandez and Valley Avenues. It was owned and operated for a number of years by David Herscher, brother of Mrs. Abraham (Bella) Greenfield, who was the wife of the owner of the Pinole Department Store on the corner of Pear Street and Tennent Avenue. (Joseph Mariotti.)

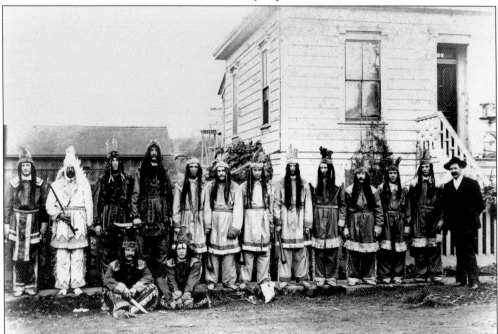

Shenandoah Tribe. The tribe was registered as fraternal club No. 121 in California in 1903. Dressed in Native American garments, the members met for entertainment, marched in local parades, and raised funds for various charities. The charter was relinquished in 1998. (Marilyn Bennett Ponting/Joseph Mariotti.)

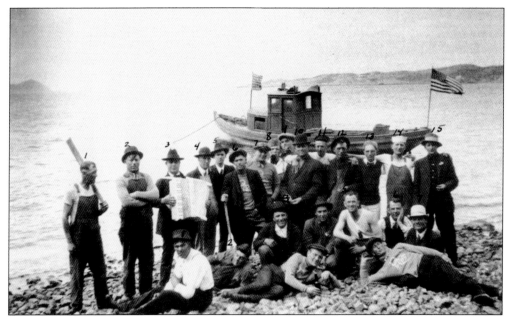

PINOLE OUTING AND ATHLETIC CLUB AT RED ROCK. In the early 20th century, Pinole, as did many towns and cities, had clubs that were the center of social activities. Some of the Pinoleans on this excursion are (seated) George Pfeiffer (6) and T. W. Woy, at the far right leaning his head on his hand; (standing) Manuel Marcos (2), Vince Scanlon (5), Molly Rose (6), Bill Lewis (7), and Jerry McDonald (10). The club was founded in 1913. (Don and Ida Castro.)

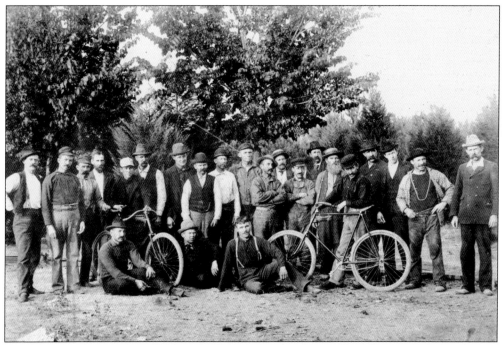

THE PINOLE BICYCLE CLUB. The bicycle club was another activity-based organization in the pre-radio, pre-television, pre-Internet, pre-iPod, pre-BlackBerry days. (Joseph Mariotti.)

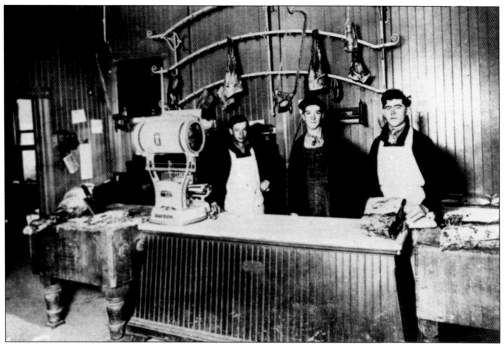

THE HOKIE SILVA AND MOLLY ROSE BUTCHER SHOP, EARLY 1900S. This shop was located on the corner of Valley Avenue and Main Street (San Pablo Avenue). From left to right are Hokie Silva, Lowell Scroggins, and Molly Rose. Hall's Garage (now the Square Deal Garage), built in 1928 by Bert Hall and later run by his son Chet, occupies this site now. (Shirley Ramos.)

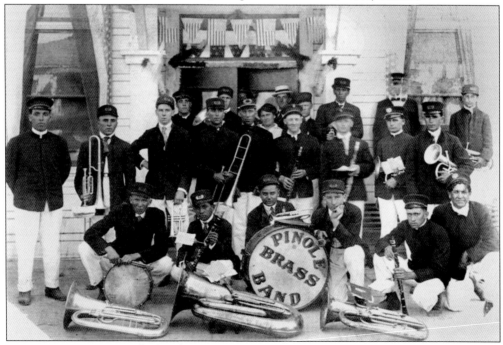

PINOLE BRASS BAND. Pinole's band was a fixture in the city's parades for much of the 20th century. This incarnation was active in the early 1900s. (Joseph Mariotti.)

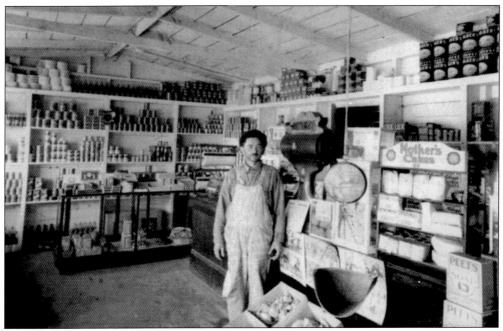

ROLLINO GROCERY. Carlos Francis Rollino and his wife, Encharita Rollino, came from Italy and arrived in Pinole in 1917. The front of their house, on a corner of First Street (now Appian Way) and San Pablo Avenue, was an Italian grocery store. Carlos worked at Hercules Powder Company until he retired. Carlos and Encharita were the grandparents of Bill Miller. The house was torn down when Appian Way was converted from a two-lane road to a four-lane road in the early 1960s. (Bill Miller.)

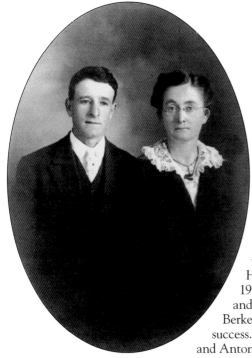

ANTONE AND ROSALINA LOPES. Antone Lopes Sr. came to Pinole in 1906 from Aveiro, Portugal, at age 24. He was a gardener at the E. M. Downer Sr. Mansion. In 1918, he tried farming, working land owned by Bernardo Fernandez. His son Antone (Tony) Jr. worked with him. In 1928, Antone Sr., together with friends Bill Faria and Manuel Duarte, signed with Heinz Cannery in Berkeley to grow tomatoes. It turned out to be a great success. Rosalina, who was from San Pablo, died in 1951, and Antone died in 1957. (Linda Rosedahl.)

Tony Lopes Jr. Tony was born in 1917 at 678 Quinan Street in Pinole. He was an only child and was delivered by Dr. Manuel Fernandez, son of Bernardo Fernandez, who was the city's sole doctor. He attended a country school in Pinole Valley that had one teacher and graduated from eighth grade in 1931; there were six graduates in his class. On March 27, 1941, nearly nine months before Pearl Harbor, he was inducted into the U.S. Army Signal Corps. He served for four and a half years. (Linda Rosedahl.)

Tony and Marian Rubino Lopes. They met in May 1939 and married on November 4, 1945, shortly after his discharge from the military. Their honeymoon, a trip through 22 states, lasted seven weeks. He worked at Mare Island in Vallejo for 32 years until his 1979 retirement. Tony and Marian lived nearly all of their married life in a home he built on property next door to his father's house on Quinan Street in 1947. Both homes still stand. In 1998, the City of Pinole named two streets after the family—Lopes Lane and Lopes Court. Marian died on July 30, 2005, and Tony died on April 1, 2008. (Linda Rosedahl.)

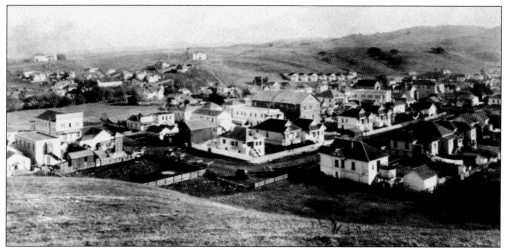

DOWNTOWN PINOLE, 1900. This photograph shows the intersection of Quinan and Park Streets in the foreground. Bernardo Fernandez built the home at 610 Quinan Street (lower right corner) in 1890. He sold it to Henry Taylor for 10 gold pieces. When Henry died, he left it to a niece, Sarah Alvarez. When she died in 1943, it went into her estate, and Mechanics Bank, which owned the mortgage, sold it to Antone Lopes Sr. Antone had been the gardener at the Downer Mansion when E. M. Downer Jr., the bank's president, was a young boy. Antone bought the home and the lot next door, which he gave to Antone Jr. to build his family home. (Linda Rosedahl.)

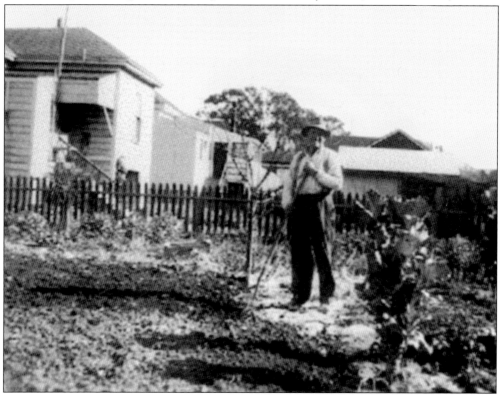

THE GARDENER. In his later years, Antone Lopes Sr. enjoyed gardening in the back of his home at 610 Quinan Street. (Linda Rosedahl.)

RAMONA MARTINEZ. This formal portrait, taken when she was three in 1903, does not portend the cruel fate that awaited Ramona, who died of cancer when she was only 18 years old. (George Vincent.)

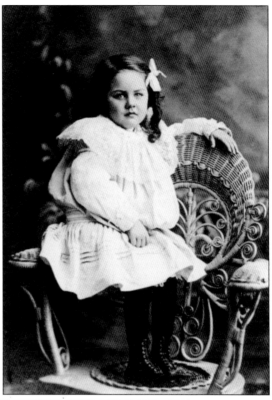

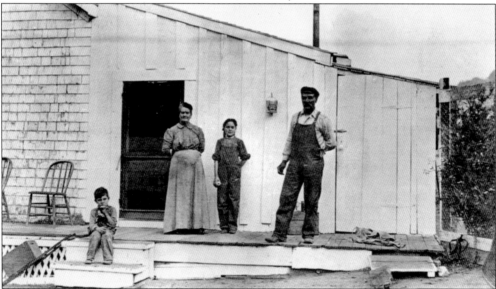

IGNACIO MARTINEZ FAMILY. The itinerant family, descendants of the man who once held title to all of Pinole, stands on the porch of their wooden cottage in Pinole Valley in 1911. Ignacio was the caretaker for the family's adobes after the 1906 earthquake. The land was then owned by Bernardo Fernandez. In this photograph are, from left to right, Little Joe (not a family member) and Emma, Ramona, and Ignacio Martinez. Ignacio was the son of Vicente and the grandson of Don Ygnacio Martinez. (George Vincent.)

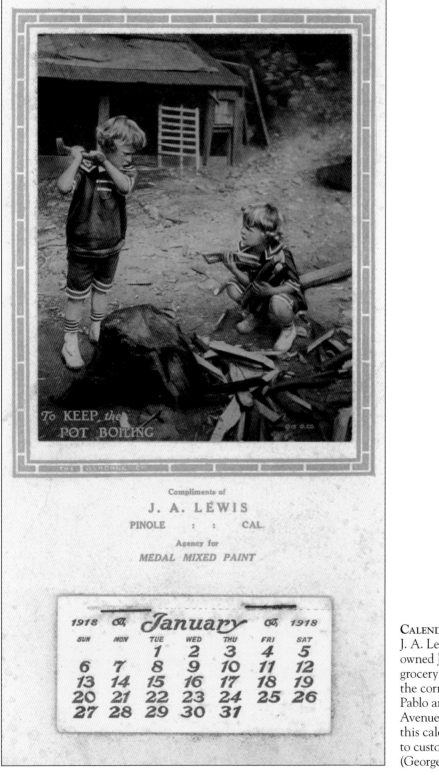

Compliments of

J. A. LEWIS

PINOLE : : CAL.

Agency for

MEDAL MIXED PAINT

1918		January				1918
SUN	MON	TUE	WED	THU	FRI	SAT
		1	2	3	4	5
6	7	8	9	10	11	12
13	14	15	16	17	18	19
20	21	22	23	24	25	26
27	28	29	30	31		

CALENDAR, 1918. J. A. Lewis, who owned Joe Lewis's grocery store on the corner of San Pablo and Valley Avenues, gave this calendar to customers. (George Vincent.)

Five

PRE-URBANIZATION ERA
1918–1958

The years 1918–1958 saw the expansion of Pinole's infrastructure and population. Until now, Pinole retained a Brigadoon-like, small-town personality and lived up to its reputation as a one-horse town. The cycle of life was this: a person was brought into the world by Dr. Manuel Fernandez, attended Pinole-Hercules School No. 1, married a local sweetheart, worked at the Hercules Powder Company or Union Oil Company, and left the world via undertaker Charlie Ryan.

Pinole maintained small-town living into the 1950s. Housewives filled their bags when tomato trucks overturned on Highway 40. Residents went to the Hercules Dynamite Box Factory for kindling for their stoves. Until 1945, cattle and cowboys kicked up dust while coming through downtown. The outside world knew Pinole as a speed trap. On one 1930s day, motorcycle Officer Lon Buck issued 30 tickets.

It was a time of community involvement and pride, even during the Depression. Pinole's ethnic backgrounds mixed together and found their fun in lodges, social clubs, sports teams, bands, and parades. In earlier years, dances at Fernandez's warehouses or clambake outings aboard his schooners were favorite activities, but in this era dances and minstrel shows were held at the Pinole Opera House. Pinole boasted a skating rink and movie theater and hosted the annual Portuguese Holy Ghost celebration. Prohibition in the 1920s had saloons renamed as "soft-drink establishments." In 1926, Greenstein's Pharmacy offered perfume for Flapper girls, and the Ku Klux Klan's initiation cross burned on the hill west of the city. Constable Arthur (Jerry) McDonald was cut down by machine-gun fire by bank robbers in 1929 and died.

Fires and floods plagued the all-wooden town, which was almost destroyed by a 1908 blaze. A 1931 fire consumed the opera house. The 1916 Pinole Creek flood created floating wooden sidewalks that were carried into the bay, and the 1940 flood left three feet of water downtown. Modern stone and brick buildings appeared downtown with the Bank of Pinole (1915) and the Pinole-Hercules Methodist Episcopal Church (1925). A municipal building with a library, jail, and firehouse was erected in 1926, and in the 1930s the Fernandez family gave the city a downtown park.

During World War II, citizens rationed butter and meat and collected scrap metal. Schoolchildren collected $3,000 for war bonds, but kids could neither get rubber balloons, nor their mothers get nylons. White-helmeted Civil Defense teams guarded Pinole Creek Bridge during blackout drills. Six servicemen died, including Dr. Fernandez's son Bernardo. Returning veterans found Pinole had changed little. By 1950, Pinole's population had reached 1,147.

DR. MANUEL LAWRENCE FERNANDEZ. Born in 1876 to Bernardo and Carlotta Fernandez, Manuel Lawrence Fernandez graduated from the University of California with a medical degree in 1900. He was a physician in San Francisco until the 1906 earthquake, at which time he returned to Pinole, where he practiced for the rest of his life. He was the physician for Hercules Powder Company from 1906 until his death in 1954. His office was upstairs in the old Downer brick building on San Pablo Avenue. In 1894, as a young man, he teamed up with Edward M. Downer Sr. to start the *Pinole Weekly Times* newspaper. (Edward Armstrong.)

DR. MANUEL FERNANDEZ AND FAMILY. Dr. Fernandez was the city's only doctor for many years. After a 1908 train wreck at what is now Pinole Shores Drive, Dr. Fernandez took a handcart from the Southern Pacific station and pumped himself down the tracks to give medical assistance to the injured on the train. Fernandez Park was a gift to the city from Dr. Fernandez. He married Bernice Burch (far right), a pharmacist's daughter, in 1917. They had three children, Bernardo, Carroll, and Charlotte, who are pictured here from left to right. (George Vincent.)

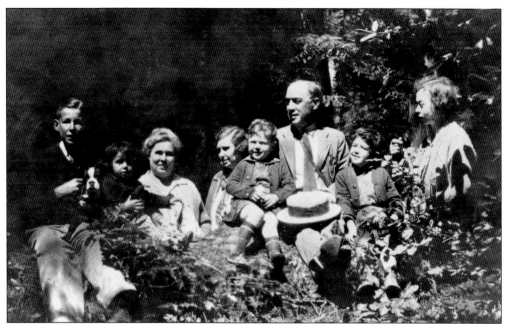

LEHMKUHL/FERNANDEZ FAMILIES IN MUIR WOODS, 1923–1924. Relaxing here are, from left to right, Jack Lehmkuhl, Charlotte Fernandez, Lillie Lehmkuhl (Jack's mother), Bernice Fernandez, Carroll Fernandez, Dr. Manuel Fernandez, Bernardo Fernandez, and the Fernandez nursemaid. The Lehmkuhls were a family of German descent. They had a home on Tennent Avenue with one of the first cement sidewalks. Lillie was a Worthy Member of the Order of Eastern Stars, the women's auxiliary of the Masons. (Joseph Mariotti.)

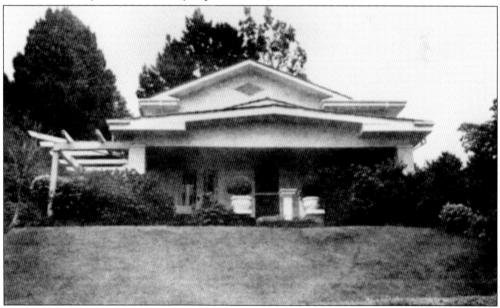

MANUEL FERNANDEZ HOME. Manuel Fernandez built his home in 1916 during World War I. Workers had to dynamite the solid rock on the building site to place the foundation. The house still stands south of the Santa Fe Railroad tracks off Tennent Avenue. In 1939, Fernandez and Edward (Ted) Hembleb opened the Buena Vista housing subdivision, one of the city's first. (George Vincent.)

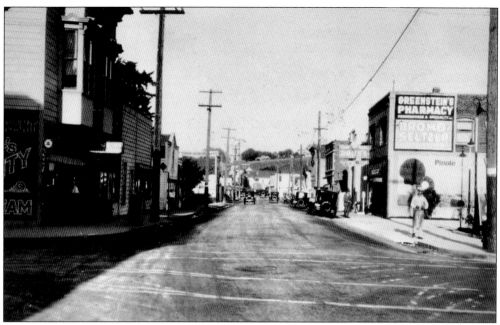

DOWNTOWN GROWING. Pinole was no longer a wooden tinderbox waiting for a match. Roads were paved, automobiles were commonplace, and a business district grew out of the ashes of the 1908 fire that devoured much of the downtown. Greenstein's Pharmacy sits in the middle of the block on Main Street, between Tennent and Fernandez Avenues, in this photograph looking east. (Joseph Mariotti.)

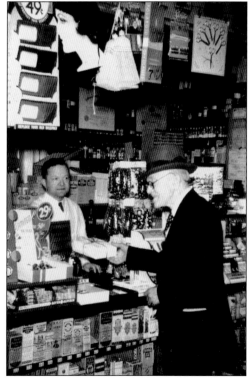

GREENSTEIN'S PHARMACY. Jacob Greenstein is pictured in his drugstore on San Pablo Avenue serving Ed Ebsen, owner and editor of the *Pinole Weekly Times*, in the late 1930s. (Joseph Mariotti.)

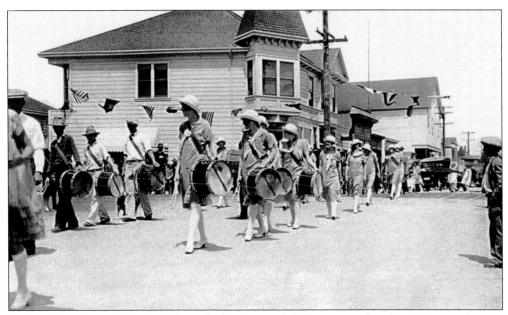

HOLY GHOST PARADE. The YLI (Young Ladies Institute) drill team marches down Tennent Avenue, crossing San Pablo Avenue in front of what is now Antlers Tavern, during the June 6, 1926, Holy Ghost celebration. In this photograph are George Vincent Sr. (fifth from left); Emily Vincent, George's wife (ninth from left); and Irma Scanlon, Emily's sister (10th from left). (Margaret Prather.)

GOLDEN WEST HOTEL. The James Silvas Building housed the Golden West Hotel (left) in the early 1900s. It was located on the southwest corner of Tennent and San Pablo Avenues, one of the Four Corners. It later housed the Joe Lunghi Trovatore Café and the Town Tavern. The Pump House convenience store and gas station is there now. (Margaret Prather.)

PINOLE-HERCULES METHODIST EPISCOPAL CHURCH. The church was organized in Pinole in October 1890. Meetings were held in Pinole's schoolhouse on the city plaza. In December 1898, when the first M. E. church was built on San Pablo Avenue near School Street (below), the church had its first regular pastor, the Reverend C. H. Darling. The Pinole-Hercules Methodist Episcopal Church (above), on Valley Avenue at the foot of School Hill, was built in 1925, when the Reverend L. D. Cook was pastor. The church was dedicated to the memory of Elizabeth Downer, wife of E. M. Downer Sr., who founded the Bank of Pinole in 1905. Elizabeth Downer was an ardent worker in the church for many years. This Valley Avenue church is now home to the Church of Christ. (Both Joseph Mariotti).

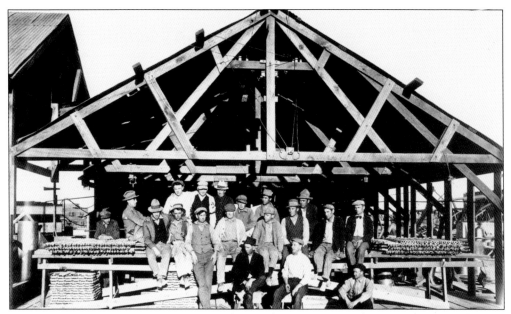

Hercules Workers at Pipe Shop. Hercules Powder Company workers are in front of the pipe shop, which is being remodeled in the mid-1930s. On occasion, workers were sent in from other jobs in the plant. (Edward Armstrong.)

George and Emily Vincent. George and Emily Vincent were married in 1923 and had two children. Emily was born in 1898 at the Scanlan Ranch in Pinole Valley. She taught in Pinole's schools for 40 years, and pupils remember her for her adobe ranch picnic outings and her plays at the Pinole Opera House. George M. Vincent was born in downtown Pinole in 1898. His father was an early Portuguese saloon keeper. George was a trombone player in the 20-piece Pinole Boys' Band, led by his uncle Bill Lewis. In 1939, George played at the Treasure Island Fair on Contra Costa Day. He was honored as Pinole's oldest senior in 1991. (George Vincent.)

KINDERGARTEN, 1920S. Teacher Gertrude Trabue poses with her kindergarten students. Pictured from left to right are (first row) Winifred Morin, unidentified, Wilfred O'Neill, unidentified, John Goularte, Ernest Goularte, and Betty Alvarez; (second row) unidentified, Carl Boivie, unidentified, Waren Lemley, unidentified, Edward (Chet) Hall, and unidentified. Trabue married Edward M. Downer Jr. She was the mother of E. M. Downer III, current chairman of the board of Mechanics Bank. (Margaret Prather.)

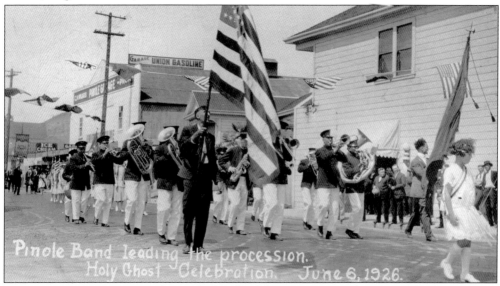

PINOLE MUNICIPAL BAND. As always, the band led the procession in the 1926 Holy Ghost Parade. (Allen Faria.)

DISEASED CATTLE. In 1924, an epidemic of hoof-and-mouth disease devastated many of the county's ranches and dairies. Trenches were dug and thousands of cattle were lined up, shot, and covered with dirt. (Joseph Mariotti.)

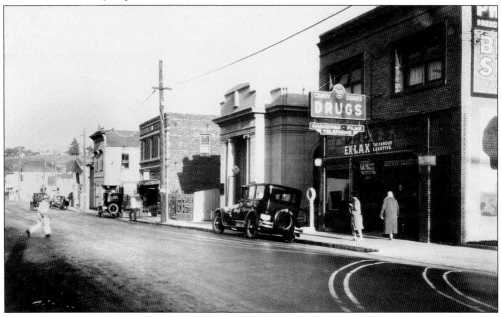

DOWNTOWN, C. 1930. The Bank of Pinole stands between Greenstein's pharmacy (the Downer Building at right) and the Ruff Building (left), two brick edifices that were severely damaged in the 1989 Loma Prieta earthquake and torn down. (City of Pinole.)

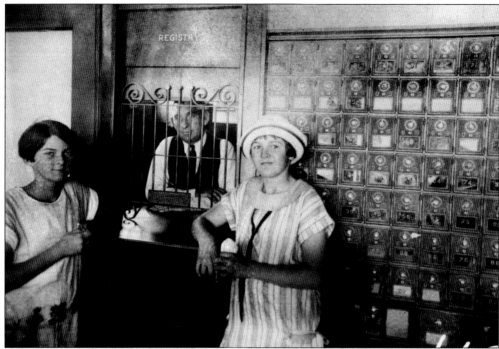

INSIDE OLD POST OFFICE. Pinole postmaster George Fraser is at the window in the old post office on Tennent Avenue. Fraser's daughter Marybelle (left) and her friend Ruth Van Dollen are in the foreground. Fraser served as postmaster in the 1920s. (Edward Armstrong.)

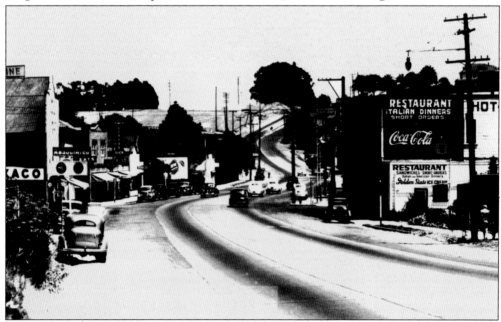

SAN PABLO AVENUE. The former Main Street became a major east-west thoroughfare as the 20th century progressed into its middle years. The Joe Lunghi Trovatore Café served Italian meals on the southwest corner of Tennent and San Pablo Avenues, seen in this photograph looking east toward Hercules. (Joseph Mariotti.)

BIG RED LEFEBVRE. Lawrence LeRoy (Red) LeFebvre managed the Pinole Merchants, one of the area's top baseball teams in the 1930s and 1940s. He was born in Pinole and worked for the Pinole-Hercules and Richmond Unified School Districts. He also worked at C&H Sugar and Union Oil Company and served on the Pinole City Council. Red had a passion for baseball, managing the Merchants before and after World War II, in which he served in the U.S. Army Artillery during the Battle of the Bulge. (Mike LeFebvre.)

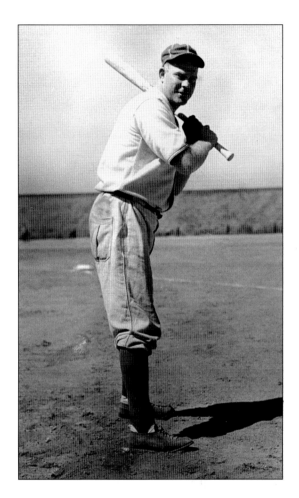

Merchantmen Come Through; Win First Game at New Park

By scoring ten runs in the eighth inning the Pinole Merchants saved the glory of Fernandez Park and beat the Crockett Club 14 to 10 last Sunday on the new diamond on the Pinole park site.

Sunday's game was the first one to be played on the new diamond, and the local fans would have left the park in gloom if the Merchants hadn't pulled the game out of the bag in the eighth inning.

Until the fifth inning neither team was able to score a run, and it looked as if the game was to develop into a pitching duel between Al Dias of Pinole and Bill Moses of Crockett. Each pitcher had allowed only one hit.

In the last of the fifth, Taylor singled for the locals to start the inning. Leverone was called out at second trying to stretch his hit into a double. Taylor scored on the play. Ed Lewis flew out to the catcher. McAndrews walked. Dias hit a long drive that was good for two bases, and scored McAndrews. Francis was out on an infield play to retire the side. Pinole lead two to zero.

In the first half of the sixth inning a triple by Wilson and a double by Sinibaldi of the visitors helped the Crockett team score four runs and take the lead.

The Pinole men tied up the game in the seventh inning when Leverone started the inning by getting to first on an error. Ed Lewis then singled and advanced Leverone to second. McAndrews got safely to first when he hit to the infield and Leverone was forced out at third. LeFebvre, batting for Dias, also got to first on a fielder's choice when Lewis was forced out at third. Francis, the next batter, got a clean single that scored McAndrews and Le Febvre to tie the score. Lemkuhl made the third out to retire the side.

A home run by Crockett's Messina and a double by Moses accounted for four runs for the visitors in the first of the eighth, and local fans were beginning to wonder if the first game at the new diamond would be won by an outside team. Eight to four was too much of a lead for the local boys to make up in only two innings. Gloom was settling over the crowd, and Ted Hemleb's voice sounded shaky over the loud speaker. It looked like a sad day for Pinole—but the Merchant baseball team had other ideas.

fairs, Ernie nonchalantly hit th best ball the Crockett pitcher ha to offer, the hit was good for fou bases and four runs. The fans wer wild. There was no more gloon Hemleb's voice took on a new ring The day was saved. Mike Lewis wa called out at first, on the next play Quinn got to first on the first base man's error. Taylor singled. Quinr and Taylor scored on an error by the Crockett second baseman. Leverone was out when he hit to shor stop.

Ten runs, seven hits, four error was the summary of the eighth inning—the inning that brought joy back to the hearts of the Pinole fans.

The Crockett boys tried their best to pull the game out of the fire in the ninth inning, but were able to score only two runs which were just four runs short of being enough.

It was a gala day for the local fans and the local team. Pinole just had to win that first game, and they did. Next to the home run by Ernie Lemkuhl, the best feature of the game was the "first pitched" ball thrown by Mayor Louis Ruff. It is reported that several big league scouts in the stands have been trying to get the Mayor to sell out his store and join one of the major league teams. The Mayor has refused all offers, however, and is concentrating on getting in shape for the formal dedication of the park that is to take place in the near future.

Lemkuhl and Taylor both collected two hits for four trips to the plate; Taylor scored three runs.

Louis Francis took over pitching duties for Pinole in the seventh inning. He allowed eight hits and six runs. Francis, however, can say that he pitched the Pinole Merchants to the first victory on the Fernandez Park diamond. Incidentally this is an honor that will become more "honorable" as the seasons go by.

The Merchants have not announced their opponent for next Sunday, but they will play at home at the new diamond.

The Merchants will meet Robak's team of Oakland on the Fernandez Park diamond Sunday.

MERCHANTS WIN FERNANDEZ OPENER. This article from the local paper glorified the Pinole Merchants, who won the first game played at Fernandez Park, 14-10, over Crockett on July 14, 1941. Pinole's Al Dias and Crockett's Bill Moses were locked in a pitchers' duel into the fifth inning, each allowing only one hit. But Pinole scored 10 runs in the eighth inning to sew up the victory. (Mike LeFebvre.)

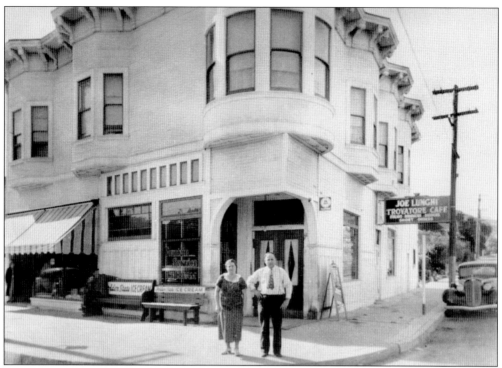

JOE LUNGHI TROVATORE CAFÉ. Joe Lunghi and his wife, Maria, stand in front of their restaurant. The Pump House occupies this site today on the southwest corner of Tennent and San Pablo Avenues. (Bill Miller.)

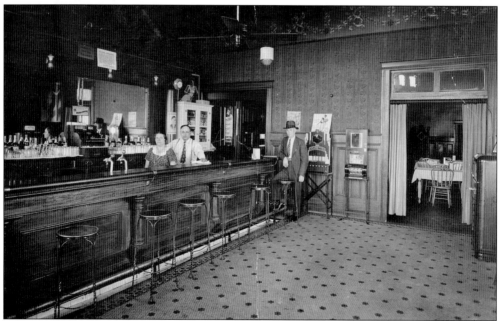

TROVATORE CAFÉ INTERIOR. Maria and Joe Lunghi are behind the bar. Patrons could dine in private booths that had curtains for privacy. Joe's son Frank moved the café across the street when he bought the Antlers Tavern. (Marlene Lunghi Perez.)

ANTLERS. This most famous of Pinole's bars began its life in 1910 as the Swenson and Lewis Saloon, owned by Jack Silva. Several people owned it in the ensuing years, most notably Frank Lunghi (1950–1976). Frank took over the Trovatore Café from his parents, then closed it when he bought Antlers, which was across the street. The Torretta family has owned the bar since patriarch Al Torretta bought it from Lunghi in 1976. (Jeff Rubin.)

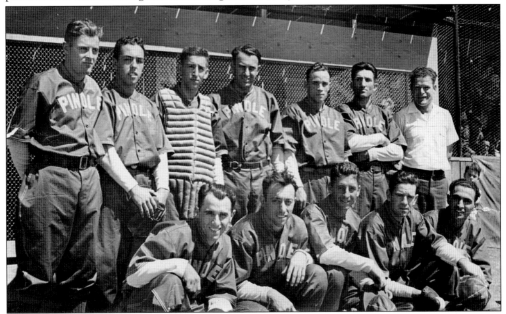

THREE BROTHERS SERVICE BASEBALL TEAM, 1940. This was one of Pinole's top teams. Pictured are, from left to right, (kneeling) Mel Marcos, Marvin Marcos, Johnny Rollino, Fred Kirkland, and Joe Garcia; (standing) Mickey Quinn, Harold Silvas, Ed Lewis, Louis Laverone, Hank Castro, Louis Francis, and Lucian DeLaBriandes (owner). (Celeste Silvas.)

AUDREY AND TONY SIMAS SR. Audrey and Tony Simas Sr. owned the largest ranch in Pinole; it was approximately 1,000 acres and extended well into Pinole Valley. Simas Avenue was named for this family. (Mary Simas.)

SIMAS FAMILY. Pictured here are Tony Sr., Tony Jr., and Audrey in 1952. (Mary Simas.)

FOUR RANCHERS. Shown here from left to right are Eddie Brazil, Linus Claeys, Tony Simas Sr., and Joe Vargas (he worked for Simas) on the Simas Ranch in the 1950s. (Mary Simas.)

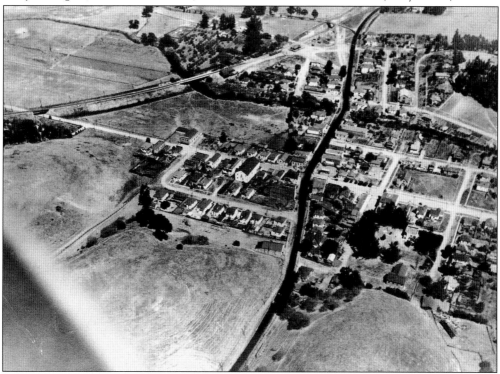

AERIAL VIEW OF PINOLE, 1925. The entire city west and north of downtown is undeveloped in this photograph taken nearly 85 years ago. Quinan and Park Streets are prominent in the center, with the Commercial Hotel still on the site of the current Fernandez Park, which was then just an empty field. San Pablo Avenue is the prominent vertical road, nearly intersecting the Santa Fe Railroad tracks to the north. (Celeste Silvas.)

ARMAND MARIEIRO ON PONY. In 1927, Armand rode this pony near his home on Quinan Street. Armand's father, Louis Santos Marieiro, and his wife, Marie, came to Pinole from Portugal in 1918. Louis worked at Hercules Powder Company for a year before moving over to the Selby smelting facility in Tormey, from which he retired after about 25 years. Armand was the father of Pinole Boy Scout Troop No. 86 scoutmaster Bob Marieiro. (City of Pinole.)

ARM'S GROCERY. Pictured from left to right, Ann, Mamie, and Armand Marieiro are in front of their grocery. Armand worked at Mare Island Shipyards during World War II. Afterward he opened this store at the intersection of Tennent Avenue and Park Street. The family operated the store for 18 years. Armand died in 1967. The grocery later became Blackie's, famous for its Maryland fried chicken and burgers. (City of Pinole.)

VETERANS' MEMORIAL PROTEST. In 1946, a group of Pinole World War II veterans requested that the city build a war memorial honoring those who had served and died. There was a hotly contested city council vote, and it did not pass. The veterans wanted to have a protest float in the Holy Ghost Parade but were turned down by parade organizers. Bee Hansen and Ed Moellman got an outhouse, put it on the back of a pick-up truck, and snuck the truck into the parade. The float was their protest statement to the city council. Among those on the truck are Ed LeFebvre (far left), Clarence Faria (head, fourth from left), and Paul Mello (suit). (City of Pinole.)

VETERANS' MEMORIAL.
On May 30, 1961,
the city dedicated
a memorial to
servicemen in
Fernandez Park. It
reads, "This plaque
is dedicated to the
young men of Pinole
who gave their lives
in World War II to
keep our country
free." (Jeff Rubin.)

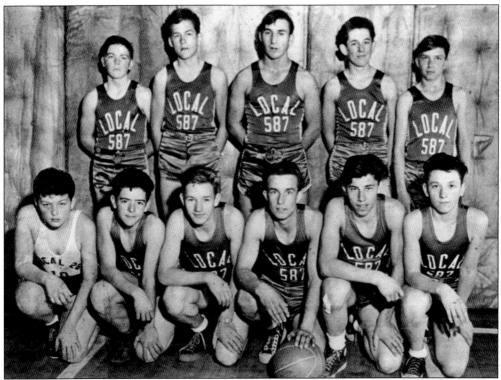

LOCAL 587 BASKETBALL TEAM, 1940S. Basketball was popular in Pinole. Pictured here are, from left to right, (kneeling) Don Castro, Marvin Dutra, Walter Anderson, Al Pimentel, Ron Silva, and Conrad Engel; (standing) Tom Butler, Bruce Marshall, Al Ramos, Donald Langford, and Verle Stromstedt. (Shirley Ramos.)

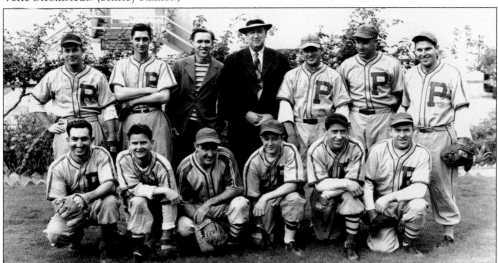

PINOLE MERCHANTS AT SAN QUENTIN. Manager Harry Skow (in suit) brought the Merchants to San Quentin Prison on October 28, 1945. The team included, from left to right, (first row) Louis Francis, Jimmy Bradley, Doyle Taylor, Aldo Banducci, Carl Monzo, and Al Hinkley; (second row) B. Cook, Robbie, Alabama, Harry Skow (manager), Joe Costa, Louie Leveroni, and F. Hart. (Margaret Prather.)

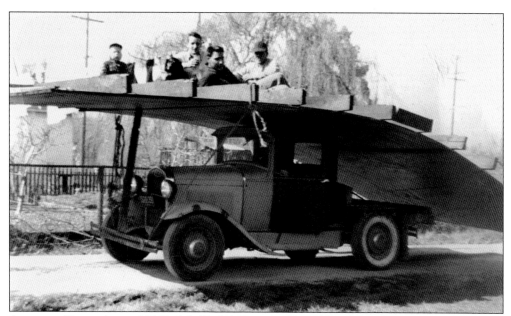

ALEX AND DUKE. Around 1955, Bob (Duke) Dutra and Harold Nelson were tearing down several old buildings on the corner of Tennent Avenue and Pear Street to get some lumber for duck blinds and to make room for the construction of the Pinole Food Center. As Alex Clark remembers, "I was walking past and yelled, 'Hey, want some help?' For the next couple of months we cleared the lot for the food center . . . we dragged timbers around and hauled them off any way we could. Many of these antics created mild comedy for the townsfolk, who put up with our efforts. Pinole was a great town then." Pictured from left to right are Jim Dutra, Alex Clark, Harold Nelson, and Bob "Duke" Dutra. (Joseph Mariotti.)

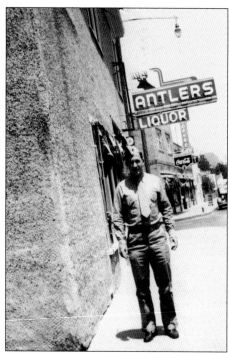

WESLEY "WES" OWENS. Wes was born in 1917 on a farm where the San Pablo Dam is today. His parents were Lily and Olaf Owens. His sister May was a teacher in Pinole and was married to Allan Doidge, Pinole's mayor in 1949. Wes served in the U.S. Marine Corps in the South Pacific for nearly four years, seeing heavy fighting in the Guadalcanal campaign. In 1944, while on leave, he met Helen McCarthy, a Pinole teacher who boarded at his parents' home on Buena Vista Drive in Pinole. They married in 1945 and built a home next to his parents. Helen McCarthy Owens taught in Pinole schools for many years. (George Vincent.)

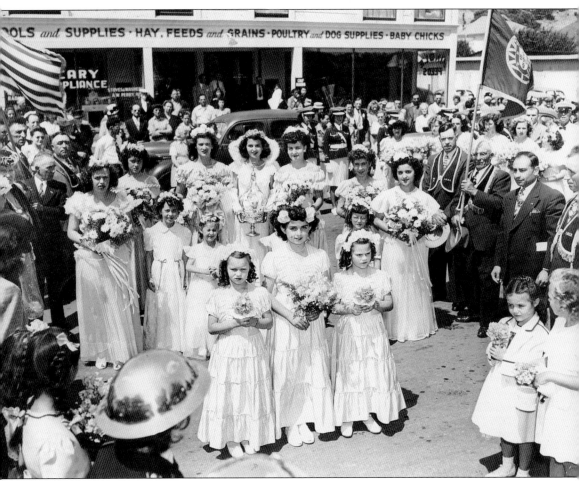

HOLY GHOST COURT, 1947. The annual Holy Ghost celebration was held under the auspices of the local IDES (Irmandade do Divino Espirito Santo; the Society of Divine Holy Ghost). The festival, originating in Portugal, is a Catholic celebration highlighted by the selection of a young woman to represent Queen Isabel. To the Portuguese, the crown symbolizes a sign of the Holy Ghost, an object of much veneration, and commemorates the day of the miracle: Pentecost Sunday. The Holy Ghost Festival traces its origins to the 13th and 14th centuries when a violent earthquake and volcanic eruption shook the Azores Islands, located 1,000 miles away from the Lisbon home of Portugal's Queen Isabel. Following the natural disasters, there was drought, crop failure, and finally a cruel famine that broke the people's faith. The people gathered to pray to the Holy Ghost for help, and what followed was a miracle. A ship arrived at the Port of Fayal on Pentecost Sunday laden with food. When the good news reached Queen Isabel, she organized a solemn procession in honor of the Holy Ghost. Accompanied by her maids, the Queen carried her crown through the streets of Lisbon to the cathedral, placing it on the altar as an offering of thanksgiving for the favors the Holy Ghost had bestowed upon her people. (Margaret Prather.)

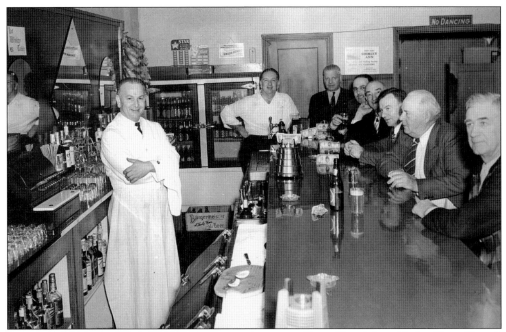

TOMMY'S CAFÉ. In 1945–1946, this business was known as Harry Skow's bar. Gladys Skow, Harry's daughter, and her husband, Tommy Prather (behind the counter), took over the business and called it Tommy's Café. It was a gathering place for coffee, conversation, and local news and gossip. It was in the same building that housed the Manuel Marcos Saloon at the beginning of the 20th century and today houses the Bear Claw Bakery. (Margaret Prather.)

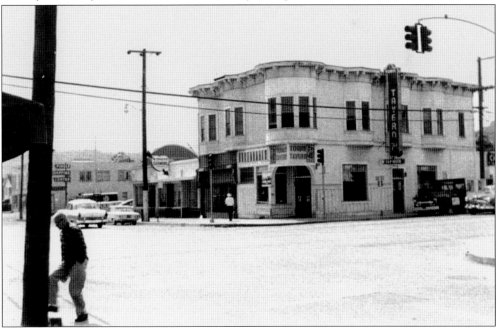

TOWN TAVERN. In the 1950s, the former Joe Lunghi Trovatore Café was known as the Town Tavern. Next door were Valentine's Cleaners and the post office before it moved to a new building on Pear Street. (Joe Mariotti.)

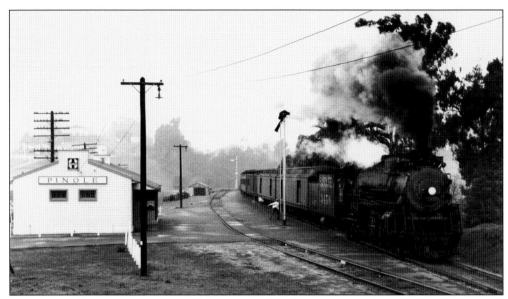

SANTA FE IN PINOLE. Above, Santa Fe locomotive No. 3450 moves eastbound through Pinole on January 21, 1950. Below, westbound Santa Fe train No. 63 approaches the Pinole depot at night. This photograph was taken before March 3, 1968, which was the last run of an Alco PA diesel to and from Richmond. The final Santa Fe depot, designed by H. L. Gilman and built in 1945, replaced the one serving Pinole from 1901 to 1944, when it burned to the ground. Gilman's design was developed for Santa Fe depots on the Coast Lines during World War II. The Pinole depot was demolished by the railroad in August 1998. (Above, Floyd McCarty; below, Robert Morris.)

Six

URBANIZATION ERA
1958–2009

The year 1958 was a turning point in Pinole. A flood and a new freeway highlighted the year that the new De Anza High School graduated its first class of Pinole seniors. Pinole Creek overflowed, leaving downtown businesses looking like islands. Tennent Avenue was a river, with boats tying up on porches. Flood control in the 1960s widened, straightened, and deepened the creek.

Interstate 80 split the town from the valley, ushering in rapid urbanization. Town boundaries expanded, and commerce and population moved away from the old central district. Pinole lost much of its small-town character. Most of Pinole's farms in the valley surrendered their pastures and fields to new subdivisions. By 1958, Pinole had 4,500 people and 10 new subdivisions. By 1969, Pinole had 13,000 people and 1,000 new houses. Cows disappeared from Pinole's hills, and so did the hills. Pinole was transformed overnight from semirural to suburban. Pinole Valley High School opened in 1967.

Unplanned growth destroyed many historic buildings. The Fernandez Mansion was threatened, and in 1968, Pinole's 1906 Hill School was torn down. Gone, too, was the Antlers Tavern bench where old-timers sat and predicted a baby's sex by which foot the expectant mother first put up on the curb. The Pinole Historical Commission (1968) and the Pinole Historical Society (1974) were outgrowths of a concern for heritage, as was the Fiesta del Pinole, held into the 1970s. Recent times have seen community redevelopment. The 1989 earthquake leveled downtown's last brick buildings, and Pinole dedicated a seismically safe city hall in 1998. Pinole's population is now 19,500.

Pinole grew from one tanbark business in 1850 to 770 businesses in 2009. It has grown from a bucket-brigade fire department and one constable in 1903 to a staff of highly skilled, full-time professional firefighters and police officers.

Today kids skateboard, use cell phones, or text one another. Satellite dishes decorate homes, a far cry from when crowds watched the first television aerial go up. The days are past when housewives looked forward to the coming of Riley's shoulder-pole fruit baskets, or Spiro, the sewing notions peddler, and the tinsmith with his wagon of pots and pans. Today green-conscious residents drive hybrid cars to Starbucks and Trader Joe's for organic foods in environmentally safe containers. The Faria House has been moved downtown from its hill, hopefully to become the city's first museum. Pinole continues to witness the ebb and flow of change seen throughout its long and colorful history.

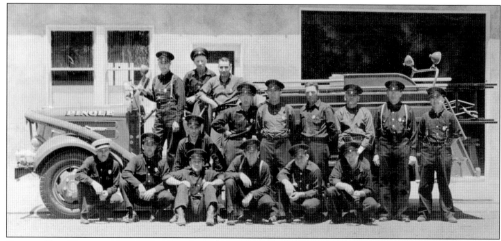

PINOLE FIRE DEPARTMENT, 1940s. These firemen are in front of the old fire station on Plum Street. Pictured are, from left to right, (sitting) Walt Barkley, Larry Pereira, Carl Fawcett, unidentified, Roy Clark, and Otto Unger; (second row) Les Silva, Everett Manning, Tony Barrocca, two unidentified, Alan Doidge, Bob Aita, unidentified, Irvin Anschutz, and George Hodgkins Sr. Before 1921, fire protection consisted of two hose carts pushed to a fire and staffed by anyone in the vicinity. Manpower consisted of volunteers until 1959, when Chief Wallace "Pepper" Martin (Pinole's sixth chief) became the city's first full-time paid fireman. (Pinole Fire Department.)

PINOLE'S FIRST ENGINE. This 1921 American La France engine was Pinole's first. George Hodgkins Sr. (left) and Carl Fawcett are the firefighters in this photograph, taken in the late 1930s or early 1940s. The red light from this engine is on the front of downtown Station 73 over the center-engine bay door. (Pinole Fire Department.)

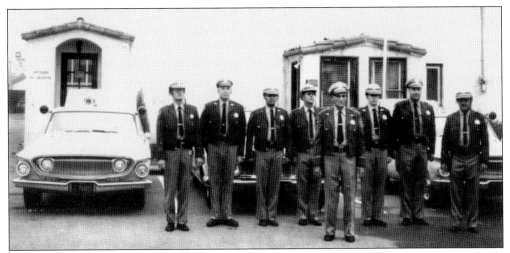

Police Department, 1962. Chief Hugh H. Young (front) stands with, from left to right, Claude Lowell Boyle, Dale Sharp, George Garcia, Art Bryant, Pete Loustelot, Lowell Thiesing, and Jim Silvia in front of the old city hall and police department. (Pinole Police Department.)

Police Tribute. This tribute on the wall in the Pinole Police Department honors the memory of the three police officers who gave their lives in the line of duty: Constable Arthur (Jerry) McDonald, who was killed during a Rodeo bank robbery in 1929; Officer John M. Sellers, who was killed by a gunman at the Antlers Tavern in 1982; and Officer Floyd (Bernie) Swartz, who was killed in a shoot-out with a murder suspect in 1980. (Jeff Rubin.)

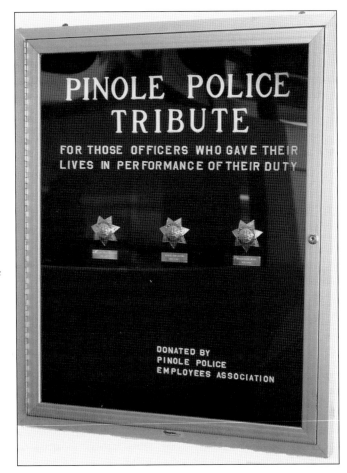

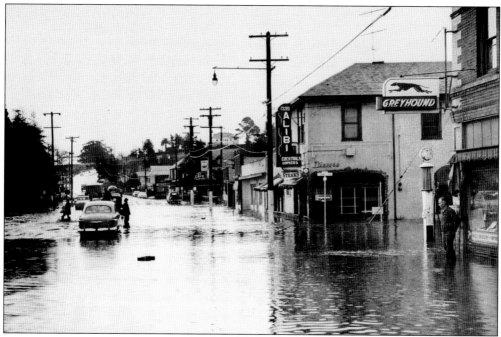

FLOOD OF 1958. On April 2, 1958, after several days of hard rain, high tides contributed to the overflow of Pinole Creek, which flooded the downtown area. Boats tied up along Tennent Avenue so the Pinole Fire Department could rescue people from their flooded homes. Boats also went up and down Tennent Avenue, which was like a river. Fernandez Park was under three feet of water. Children got on the bridge connecting Valley Avenue with Prune Street in makeshift rafts and "surfed" down the creek. In the 1960s, the U.S. Army Corps of Engineers came to Pinole and widened, straightened, and deepened the creek. The corps took only three homes to realign the creek, and downtown Pinole has not flooded since. (Above, Margaret Prather; below, Joseph Mariotti.)

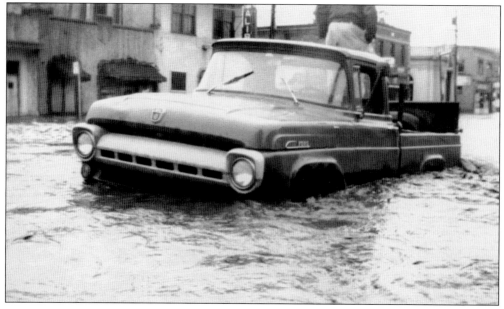

TOMMY PRATHER. Fire captain Tommy Prather is asleep at the wheel in a duck blind. As a member of Ducks Unlimited and the California Water Fowl Association, Tommy raised funds to protect the wetlands and preserve the wildlife. A longtime Pinole resident known for his friendly pranks, Tommy was a 17-year veteran of the Pinole Fire Department, 13 years as a captain. Tommy and his wife, Margaret (Faria) Prather, owned Tommy's (formerly the Three Belles), the "Cheers" of Pinole and one of the city's most popular restaurants and bars. The restaurant was open from 1980 to 1999. Tommy died in 1997. (Above, City of Pinole; below, Margaret Prather.)

JERRY DEUKER AND FOWL FRIEND. Pinole Valley High School football coach Jerry Deuker speaks at a Thanksgiving Day bowl game. Deuker was the first in a short line of great head football coaches at the school, followed by Jim Erickson and Steve Alameda. They coached some great players, including Eddie Ayers, Dale Sveum, Darrick Brilz, Forey Duckett, Dedric Holmes, Chris Singleton, Don Toomer, Mark Williams, Dan Han, Jeff Taylor, Terry Zahner, Mike Bradeson, Jim Alexander, Jeff Kondra, twins Samuel and Sandor Manuel, Marcus Maxwell, Thomas DeCoud, Mario Washington, Castine Bridges, Wopamo Osasai, and the 1992 Heisman Trophy winner, Gino Torretta. The school's field is named Deuker Stadium. (Applebee's.)

JIM ERICKSON ON THE FIELD. Coach Erickson succeeded Deuker and coached at Pinole Valley High School from 1982 to 2001. He was the athletic director while he coached and for a while after he stepped down. He started at the school in 1973 and retired June 2008. (Jim Erickson.)

Gino Torretta Wins Heisman. The Torretta family attended the 1992 Heisman Trophy award ceremony at New York's Downtown Athletic Club. Gino (light suit, second from right) quarterbacked the University of Miami's 1991 national championship team. Gino passed for more than 3,000 yards his senior year in 1992 and won the Heisman Trophy (best player) and the Davey O'Brien Award (top college quarterback) that season. He was elected to the College Football Hall of Fame in 2009. (Geoff Torretta.)

Darrick Brilz. A 1983 Pinole Valley High School graduate, Darrick played college ball at Oregon State University. An offensive lineman, he had a 12-year National Football League career, mostly with the Seattle Seahawks and Cincinnati Bengals. Darrick owns a Super Bowl ring as a member of the Washington Redskins, who defeated the Denver Broncos 42-10 in the 1988 Super Bowl. (Oregon State University.)

MARGARET COLLINS. Margaret Collins (wearing a corsage) was honored at her retirement dinner. Fellow teachers included, from left to right, (seated) Theresa Maloney; (standing) Catherine Beavers and Genia Litman. Collins was a student at the old Plaza School before Pinole-Hercules School No. 1 was built. She taught third grade at the Pinole-Hercules School No. 1 until becoming principal in 1942 after Frances Ellerhorst retired. She was superintendent of the Pinole-Hercules Elementary School District until 1965 when the district was absorbed into the new Richmond Unified School District. Collins School on Pinole Valley Road (formerly Pinole-Hercules School No. 2) is named after her. (Wayne Doty/Pinole Historical Society.)

GEORGE R. VINCENT. George's parents were Emily and George Vincent. George followed his mother into teaching and taught for 42 years in local schools. He was a good baseball player, hitting .340 for the Pinole Merchants semipro team in 1966. He and his wife, Christie, have three children. He was the first president, in 1968, of the Pinole Historical Commission. In 1995, he was selected as one of West Contra Costa's teachers of the year. He has written books on local history and families and is vice president of the Pinole Historical Society. (George Vincent.)

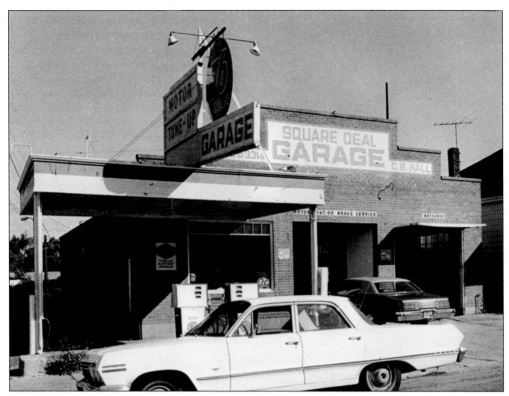

HALL'S GARAGE. The Square Deal Garage operated first in the Fraser blacksmith shop on San Pablo Avenue across from the Alibi, one of the many downtown bars. Bert Hall built this garage in 1928 on the corner of San Pablo and Valley Avenues. Bert's son Chet Hall ran it for many years. (City of Pinole.)

FORMER HOLY GHOST QUEENS. Gathering at a 1994 Holy Ghost reunion at San Pablo's Alvarado Square are, from left to right, (sitting) Marcia Marcos, Carol Costa, Deanna Faria, Jeri Nunes, and Margaret Faria; (standing) Mary Ann Pavon, Celeste Freitas, Laverne Nunes, and Dolores Faria. (Margaret Faria).

LOUIS FRANCIS. Louis (left, with former city manager Don Bradley) was born in the early 1900s. As a young man, he was a professional boxer. Pinole baseball teams had no home field, and Louis asked the city if he could make a baseball diamond at the new downtown park site donated by Dr. Manuel Fernandez. The "park" was grass and weeds. Louis and his baseball team graded the land and put in dugouts, parking, and a grandstand for free. From the 1940s to 1960s, Louis meticulously laid out and cared for Fernandez Park and its plants, benches, and barbeque pits—all for no pay. Louis worked in the dynamite-mixing plant at Hercules Powder Company and survived the 1953 explosion that killed 12 men. Louis Francis Park was named for the man who beautified Pinole's first park. (Wayne Doty/ Pinole Historical Society.)

DR. JOSEPH MARIOTTI. Dr. Joe, a cofounder of the Pinole Historical Society, was an orthopedic surgeon and team doctor of the Pinole Valley High School football team. Joe and his late wife, Gretchen, were members of the Pinole City Council and made the Fernandez Mansion their home. The Mariottis saved the Fernandez Mansion from destruction and were instrumental in getting it listed on the National Register of Historic Places. (Applebee's.)

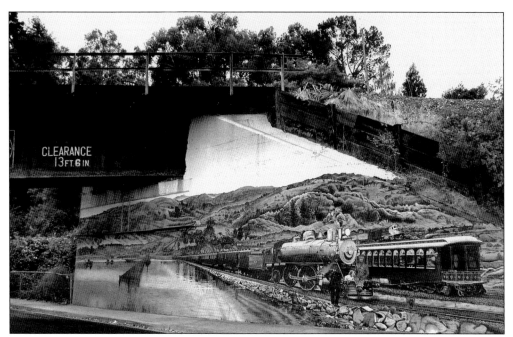

MURALS. Pinole has a thriving arts community. The Pinole Artisans has a gallery downtown next to city hall and murals abound throughout the community—under the Interstate 80 overpass, along San Pablo Avenue, and on the sides of downtown buildings. This mural, by Stefen, is under the Santa Fe train trestle and was dedicated on June 25, 2003, the centennial of the city's incorporation. (Jeff Rubin.)

FERNANDEZ PARK. Dr. Manuel Fernandez donated the land for this park to Pinole, and it has become the focal point of the community's recreation life, especially during the summer when basketball games are played nonstop, children romp in playgrounds, and the city hosts weekly outdoor concerts and movies. (Jeff Rubin.)

ANNE WALSH. Anne graduated from Pinole Valley High School in 1991 as one of the most dominant softball pitchers in Northern California history. She played three varsity years. In her last year, the team won the North Coast championship. She received an athletic scholarship to UC Berkeley and was a 1996 Academic All-American. (California Athletic Department.)

JONTELLE SMITH. Jontelle (no. 22, shooting) is a 2005 graduate of Pinole Valley High School. She was named the basketball team's Most Valuable Player three times, was all-league three years, and was a two-time MVP of the Alameda-Contra Costa Athletic League. At St. Mary's, she is a 1,000-plus point scorer and has made the All-West Coast Conference team three times. Other PVHS female athletes of note include Stephanie Tamayo in softball and basketball stars Jasmine Smith (Jontelle's sister, also at St. Mary's), Jalessa Ross, Marnique Arnold (Fresno State), and DeNesha Stallworth (a McDonald's All-American who will attend UC Berkeley on a scholarship in the fall of 2009). (St. Mary's College.)

BETTY GRIMES. Betty served as Pinole City Clerk from 1960 to 2000. She was affectionately known as the "Barracuda," a name she frequently used about herself, as it referred to her relentless attention and devotion to her duties. The council chambers in the new city hall were dedicated on November 21, 1998, in the name of Elizabeth "Betty" Grimes. Betty was involved with the League of Women Voters, League of California Cities, the Republican National Committee, and the Pinole Chamber of Commerce, which named her its Woman of the Year in 1968. She was a PTA and Sweet Adelines member and cofounded the Fiesta del Pinole. Betty died in 2006. She was 81. (Wayne Doty/Pinole Historical Society.)

PINOLE GARDEN CLUB. Founded in 1956, the club is dedicated to the city's beautification. It had reached 53 members by the end of 2008. The club sponsors a yearly front-yard landscaping contest, conducts programs in Pinole's elementary schools, holds a holiday candy cane contest for children at the Pinole Library, and maintains the Pinole Welcome Wall at Interstate 80 and Pinole Valley Road. Pictured here from left to right, members Nancy Snodgrass, Pat McDonald, and Emmy Swanson work on the Welcome Wall cleanup. (Pinole Garden Club.)

CHRIS SINGLETON. Chris was an all-league star in basketball and baseball at Pinole Valley High School, graduating in 1990. He received a football scholarship to the University of Nevada, Reno as a wide receiver and started three years for the Wolf Pack. He chose baseball as his professional sport and was drafted by the San Francisco Giants in 1993. He made his major-league debut with the Chicago White Sox in 1999 and played six seasons for the White Sox, Baltimore Orioles (2002), Oakland Athletics (2003), and Tampa Bay Devil Rays (2005). He was the color commentator on Chicago White Sox radio broadcasts for the 2006 and 2007 seasons and is now an analyst on the ESPN television program *Baseball Tonight.* (Ron Vesely-Chicago White Sox.)

DALE SVEUM. He was an All-State and All-American quarterback at Pinole Valley High School, graduating in 1982. He was drafted by the Milwaukee Brewers in the first round (25th pick) of the 1982 amateur baseball draft and went on to play 12 major league seasons. Sveum's best season was 1987 when he hit 25 home runs and drove in 95 runs while batting mostly in the ninth spot in the Brewers' lineup. Sveum was the third base coach for the Boston Red Sox from 2004 to 2005. In Boston, Sveum worked under his former Brewers teammate Terry Francona and the team won the 2004 World Series. He left the Red Sox to rejoin the Brewers as the team's bench coach and was named interim manager of the team after manager Ned Yost was fired in September 2008. He is now the Brewers' hitting coach. (Applebee's.)

PULITZER PRIZE WINNER. A two-time Pulitzer Prize winner in photojournalism, *Washington Post* photographer Michael S. Williamson was a high school All-American runner at Pinole Valley High School in the 1970s. Michael was born in Washington, D.C., and reared in several foster homes before settling with a permanent foster family at age 12—Ray and Mary Ann Agee, who lived in Pinole's Linda Heights. The Agees live in Oregon now, and Michael still keeps in touch with them. Michael lives in Silver Spring, Maryland. (Michael S. Williamson.)

PRIZE-WINNING BOOK. Michael Williamson's first newspaper job was at the *Pinole Progress* (later part of the *West County Times*), where he did reporting and photography. He joined the *Washington Post* in 1993. He previously worked at the *Sacramento Bee* (1975–1991) and taught at Western Kentucky University (1991–1993). Michael has covered a variety of global events in the last 30 years, including the wars in El Salvador and Nicaragua, the Philippine Revolution, strife in the Middle East, the Gulf War, and conflicts in Africa and the Balkans. His work on the homeless has yielded three books, including *And Their Children After Them* (coauthored with Dale Maharidge). It won the 1990 Pulitzer Prize for a nonfiction book. In 2000, he shared the Pulitzer Prize in feature photography for coverage of the conflict in Yugoslavia. (Michael S. Williamson.)

121

JOHN BRYANT. A 2005 graduate of Pinole Valley High School, John (54) was one of the dominant basketball players in the West Coast Conference for four seasons at Santa Clara University, where he was a perennial all-WCC selection and WCC Player of the Year as a senior in 2008–2009. At PVHS, he was a first-team All-Alameda-Contra Costa Athletic League pick. (Santa Clara University.)

YOUTH CENTER AND PLAYHOUSE. The Pinole Youth Center (right) and the Pinole Community Playhouse (left) sit at the entrance to Fernandez Park on Tennent Avenue, a thoroughfare people once traveled in horse and buggy on a dirt street to get to and from downtown and the Southern Pacific depot. The youth center, which opened in 2006, is a gathering place for the young people of the community, and there are myriad activities there every day. The playhouse opened in 1991 when the Pinole Community Players leased Pinole Memorial Hall. The playhouse is also home to the School of Performing Arts. Hundreds of actors take part in shows and classes during the year. The Pinole Community Players, founded in 1986, oversees the Pinole Young Actors and shepherds many local youth into the performing arts. (Jeff Rubin.)

GREEN DAY. Billie Joe Armstrong (left) and Mike Dirnt (bottom), along with Tré Cool (right), form the wildly successful punk rock trio Green Day, which has won three Grammy awards. Billie Joe and Mike were childhood friends and attended Pinole Valley High School. They got their first gig at Rod's Hickory Pit, where Billie Joe's mother, Ollie, worked. Billie Joe and Mike have been performing together in various bands since 1987. Green Day is one of the world's most popular rock bands with over 60 million records sold worldwide. Their 2004 album, *American Idiot*, received six Grammy nominations and is being made into a Broadway show. The group's latest album, *21st Century Breakdown*, was released in May 2009 (Ollie Armstrong.)

KRISTY CATES. Now a musical star, Kristy performed in many community theater productions during her seven years with the Pinole Young Actors group. She performed nationally in *Wicked* in the role of Elphaba, seen here, and was in the show's original Broadway cast. Kristy has performed at numerous clubs across the United States as well as the Tony Awards, on the *Late Show with David Letterman*, and in the Macy's Thanksgiving Day Parade. This photograph was autographed by Kristy and given to Debbie Ojeda, who has long been involved in the Pinole Young Actors. (Debbie Ojeda.)

PINOLE RECALL. In 2007, a citizens group called the Concerned Citizens of Pinole sponsored a recall to remove three of the five members of the Pinole City Council—Maria Alegria, David Cole, and Stephen Tilton. The group held rallies, gathered signatures on petitions for three months, and met the qualifications for a recall election. Alegria and Tilton were recalled on February 5, 2008; Cole had resigned and a special election was held to fill his seat. (Jeff Rubin.)

SCHOOL BELL. This bell once rang for students at the Pinole-Hercules School No. 1 (the Hill School). After the school was torn down in 1968, the bell was moved to Pinole Middle School. When that school was remodeled in 2007–2008, the Pinole Historical Society persuaded the school district to move the bell to Collins Elementary School, where it awaits a permanent display. (Jeff Rubin.)

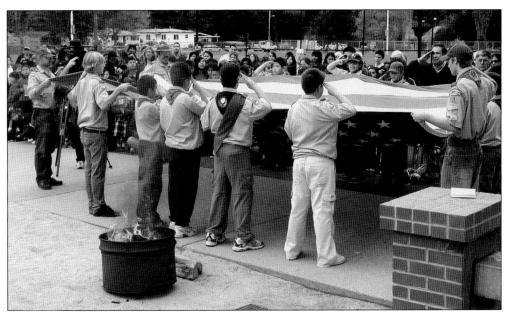

FLAG RETIREMENT CEREMONY, 2008. The Pinole Historical Society and the Pinole Community Services Commission sponsored the city's first Veterans' Day Memorial and Flag Retirement Ceremony on November 11, 2008, the 90th anniversary of the armistice that ended World War I. Veterans from VFW Post 2798 raised the flag, the Pinole Valley High School Marching Band played an array of tunes, the entire student body of St. Joseph School sang patriotic songs, and Boy Scout Troop 86 retired 20 worn U.S. flags in a moving ceremony inside Fernandez Park. More than 500 people attended. (Both Jeff Rubin.)

WILLIAM (BILL) FARIA AND THE FARIA HOUSE. Bill worked at the Hercules Powder Company and raised dairy cows on his father's ranch (across Pinole Valley Road from this home) in the 1920s and 1930s. Known as the "Tomato King," he was a tomato farmer in the Willows Flats in Hercules in the 1940s and a cattle rancher in the 1950s. He died in 1986 at age 92. The Faria House, in which he reared his children, was moved to downtown Pinole in 2005 to make way for the Kaiser Permanente Medical Office Building. (Margaret Prather.)

KAISER PERMANENTE MEDICAL OFFICE BUILDING. The hospital giant opened a medical office building on the former site of the Faria House on January 12, 2009. (Jeff Rubin.)

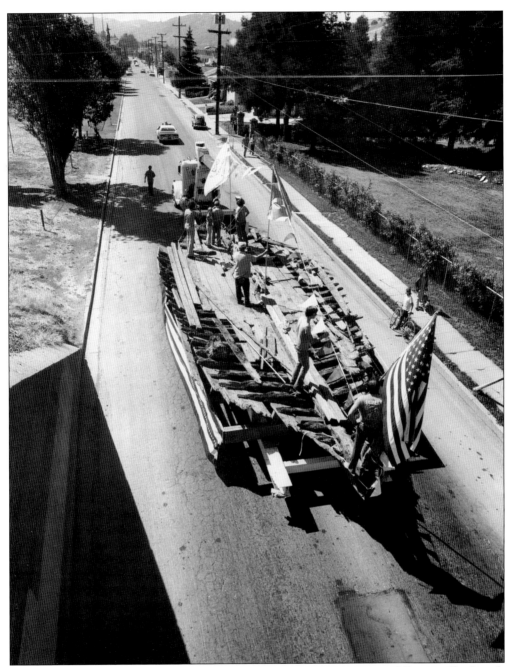

THE CARLOTTA. This is the 1976 Pinole Historical Society Bicentennial Project. Dr. Joseph Mariotti's Ship Lifters of Pinole (SLOP) resurrected a two-masted, 52-foot-long schooner that belonged to Bernardo Fernandez. It sank in the early 1900s at the Fernandez Wharf. The schooner was named the *Carlotta*, after Fernandez's wife. Seventy SLOP volunteers, watched by 100 people on shore, dug and lifted the *Carlotta* by barrel floats and tow trucks from its resting place deep in the mudflats at low tide. It was on public display at the Antlers Tavern before being moved to the Fernandez Mansion, Mariotti's home, where its remains remain, a fitting resting place on the grounds of the boat's namesake's home. (Joseph Mariotti.)

Across America, People are Discovering
Something Wonderful. Their Heritage.

Arcadia Publishing is the leading local history publisher in the United States.
With more than 5,000 titles in print and hundreds of new titles released every
year, Arcadia has extensive specialized experience chronicling the history of
communities and celebrating America's hidden stories, bringing to life the people,
places, and events from the past. To discover the history of other communities
across the nation, please visit:

www.arcadiapublishing.com

Customized search tools allow you to find regional history books about the town
where you grew up, the cities where your friends and family live, the town where
your parents met, or even that retirement spot you've been dreaming about.